Vibrant Flowers in Watercolor

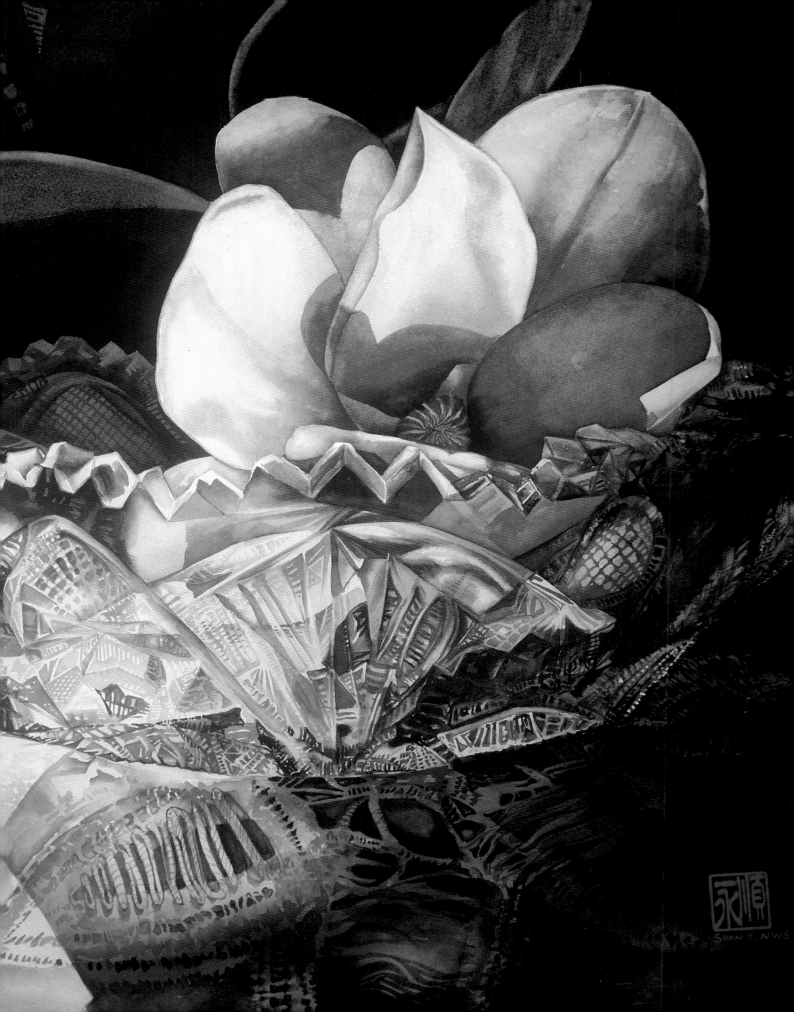

Vibrant Flowers

IN WATERCOLOR

Soon Y. Warren

NORTH LIGHT BOOKS
CINCINNATI, OHIO
www.artistsnetwork.com

fw
F+W PUBLICATIONS, INC.

lished by North Light Books, an imprint of F+W Publications, Inc., 4700 East Galbraith Road, Cincinnati, Ohio, 45236. (800) 289-0963. First Edition.

Other fine North Light Books are available from your local bookstore, art supply store or direct from the publisher.

10 09 08 07 06 5 4 3 2 1

DISTRIBUTED IN CANADA BY FRASER DIRECT
100 Armstrong Avenue
Georgetown, ON, Canada L7G 5S4
Tel: (905) 877-4411

DISTRIBUTED IN THE U.K. AND EUROPE BY
DAVID & CHARLES
Brunel House, Newton Abbot, Devon, TQ12 4PU,
England
Tel: (+44) 1626 323200, Fax: (+44) 1626 323319
Email: mail@davidandcharles.co.uk

DISTRIBUTED IN AUSTRALIA BY CAPRICORN
LINK
P.O. Box 704, S. Windsor NSW, 2756 Australia
Tel: (02) 4577-3555

Library of Congress Cataloging in Publication Data
Warren, Soon Y.
 Vibrant flowers in watercolor / by Soon Y. Warren.--
1st ed.
 p. cm.
 Includes index.
 ISBN-13: 978-58189-707-3 (alk. paper)
 ISBN-10: 1-58180-707-4 (alk. paper)
 1. Flowers in art. 2. Watercolor painting--Technique. I. Title.
 ND2300.W37 2006
 751.42'24343--dc22 2005020563

Edited by Vanessa Lyman and Erin Nevius
Art direction by Wendy Dunning
Designed by Barb Matulionis
Production coordinated by Mark Griffin
Art page 2: *Purple Magnolia* (22" × 30" [56cm × 76cm]) 220-lb. (462gsm) cold-press Waterford

DEDICATION

I dedicate this book to my mother, whose love of flowers introduced me to flowers and gardening, and to my husband, Peter, whose support and encouragement made my lifelong dream of painting possible and enjoyable.

ACKNOWLEDGMENTS

My most sincere thanks go to the North Light Books staff, who worked hard to put together the materials I delivered for this book.

In particular, I'd like to thank Jamie Markle, executive editor, who helped me foster the book idea; Layne Vanover, editor, who patiently guided me through the beginning of the project with step-by-step instruction about how to develop the details of the book; and Vanessa Lyman, editor, whose dedication, talent and effort transformed my original manuscript into a completed book. I also thank Erin Nevius, Barb Matulionis, Lauren Eisenstodt and Carol O'Connor. Finally, my thanks to Mark Griffin, the production coordinator, who made sure everything looked good through the final printing process of the book.

My sincere, special thanks go to my husband, Peter, who understands my English as a second language better than anyone. With support and love, he proofread every draft to make sure my editor could understand my words, from the initial proposal to the final version of the book. I also am indebted to my family, especially my sister Myong Young, for believing in me and lending support and encouragement. My fellow artists, whose encouragements are an inspiration in my life, also deserve many thanks.

CLAMATIS
15" × 22" (38cm × 56cm)
140-lb. (300gsm) cold-press
Winsor & Newton

Metric Conversion Chart

To convert	to	multiply by
Inches	Centimeters	2.54
Centimeters	Inches	0.4
Feet	Centimeters	30.5
Centimeters	Feet	0.03
Yards	Meters	0.9
Meters	Yards	1.1

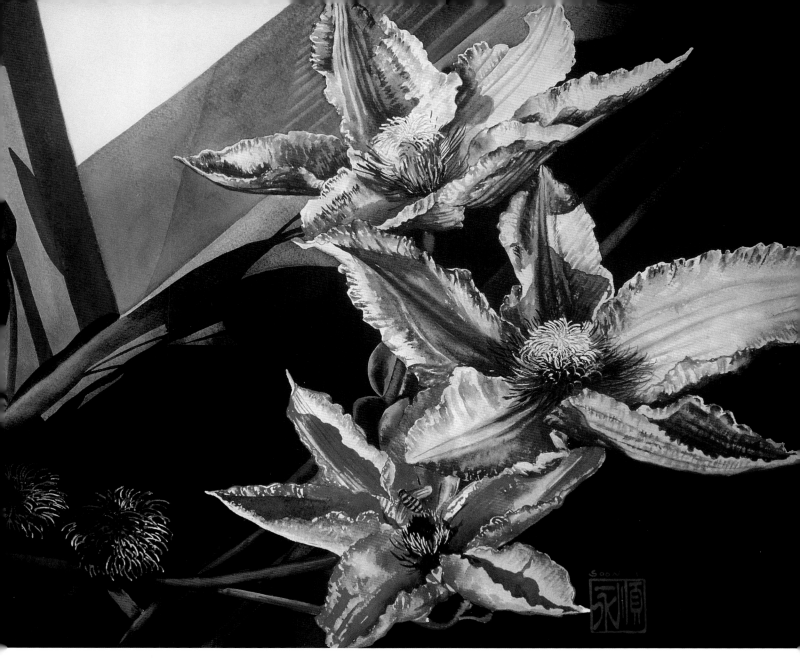

ABOUT THE AUTHOR

After moving to the United States from South Korea, Soon Y. enrolled at Thomas Nelson Community College (TNCC) in Hampton, Virginia, where she earned a degree in commercial art. She worked in the TNCC public relations department as a computer graphic designer upon graduation.

Since moving to Fort Worth, Texas, in 1998, Soon Y. has returned to painting and has had several exhibitions and earned numerous awards. She is a signature member of the National Watercolor Society (NWS), Southern Watercolor Society (SW), Texas Watercolor Society (TWS) and Society of Watercolor Artists (SWA). She is one of the featured artists in *Splash 8: Watercolor Discoveries*, North Light's annual magazine cover contest. Soon Y. won an honorable mention in the animal category of *The Artist's Magazine*'s 2005 competition and fourth place in *Watercolor Magic* magazine's competition.

She paints and teaches at her studio, gives demonstrations and workshops for artist organizations, perfects her gardens, and finds time to spend with her husband, Peter Warren.

Table of Contents

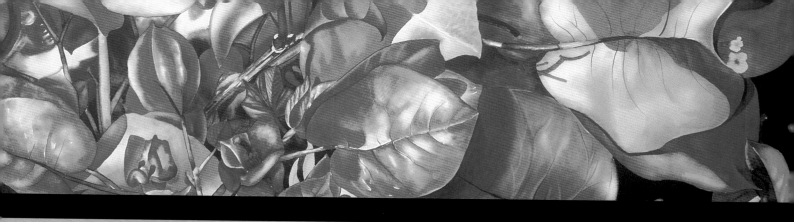

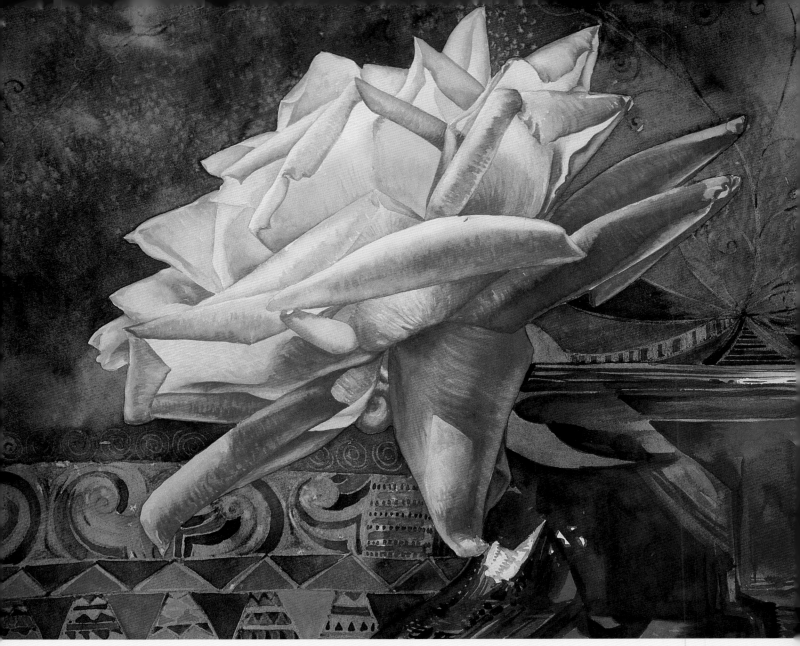

YELLOW AND BLUE
15" × 22" (38cm × 56cm)
140-lb. (300gsm) cold-press Winsor & Newton

INTRODUCTION

How wonderful and awesome the watercolor medium is! It expresses the personality of its subjects very delicately, using simple brushstrokes plus a little discipline and competence. It's your choice how you express your thoughts, starting with what paper you use all the way to how you sign your work. There are no unbreakable rules in watercolor painting! However, understanding several very basic principles and elementary techniques, then finding your style and spending a lot of time painting, are necessary in jump-starting your painting process. There is one more very important talent you'll need to cultivate in order to execute outstanding representational paintings: patience, patience and patience with a passion for painting.

Even though there are many different approaches and theories in painting, this book concentrates on how to paint powerful floral images step-by-step using stress-free methods. Drawing, washing, glazing and detailing are all easier to approach when there's a little organization before picking up the pencils, brushes and pigments. Of course, unexpected directions, sometimes misunderstood as mistakes, may arise to frustrate you; but I always believe that my unsuccessful first attempts on a painting are learning experiences that will enrich my second attempt.

Instead of fearing the unknown, I get excited and curious when presented with an opportunity to explore new terrain. Unexpected results when mixing colors on the palette or compositions that just don't feel right seem like dreadful and never-ending problems, but are also opportunities to learn and grow!

There are many exciting and spontaneous watercolor techniques that allow great freedom and fun in your work, though you will sometimes find a piece going nowhere and experience great frustration. In this book, I break down complicated painting processes into very basic steps using

fundamental techniques. In the end, every great painting is built up of basic techniques, layer by layer.

In a classroom full of students, each uses color and portrays shape differently though they're using the same model and paints. This individualism is an unavoidable trait of human nature. Everyone paints differently! If you learn to comfortably embrace new ideas, you can approach every painting with different ideas and styles in mind. It's a challenge to make each piece special in its own way. There are no formulas for the perfect painting. Once you are familiar with the basic techniques, how you express your plan is all yours and only yours. Try to experiment and paint beyond your comfort zone.

Setting aside a portion of every day for painting will make a great difference in your artistic career. Once you start painting daily, you will often be frustrated and hit what seem like immovable plateaus. However, you will also feel the great joy and satisfaction of achievement as you progress through each new level of artistic ability.

When you're satisfied with how a painting is progressing, it's easy to be afraid of putting on more colors. You don't want to ruin what is so far a beautiful painting, even though it is not yet complete. Don't be afraid of making mistakes! When you think a mistake has been made, stop and figure out a different direction for the painting to go. If you have no idea about how to fix it, put the painting aside for awhile. One day, an idea will come to you and at that time you will be able to complete the painting.

I believe that by plunging your heart into watercolor painting, you will learn and understand the uniqueness of the medium. With that knowledge, you can control your craft and be spontaneous and loose; and you alone, the artist, will see the unique magic of artistic anticipation.

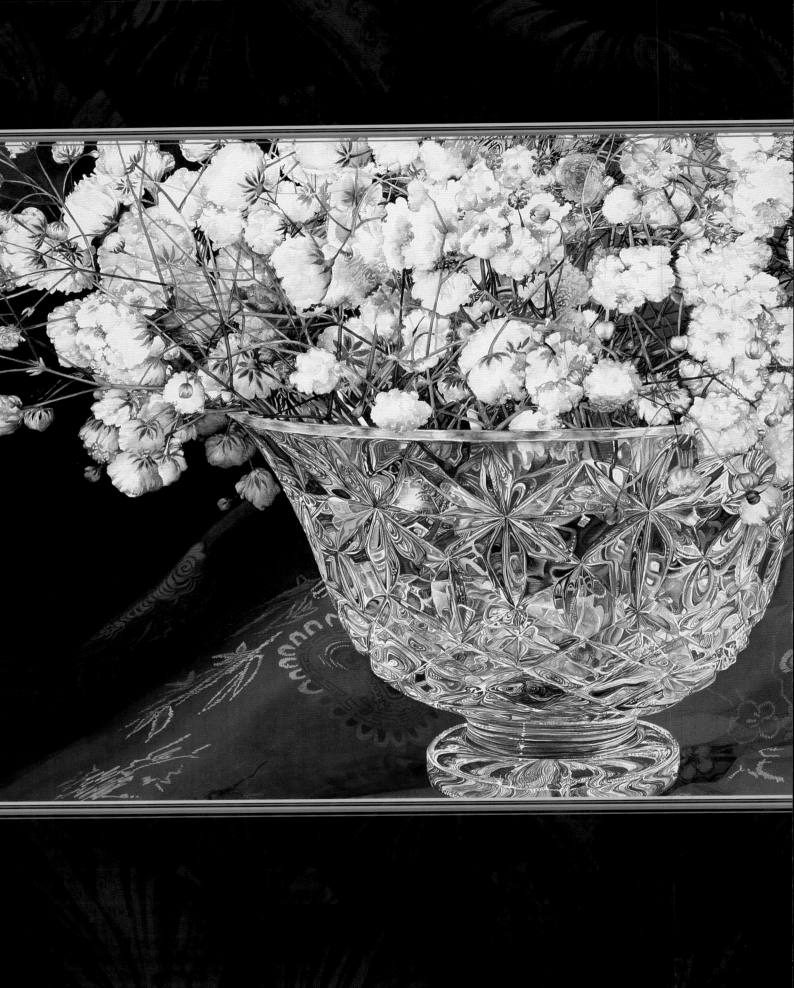

Getting Started

All the great materials available today at reasonable prices are a blessing and a privilege that artists often take for granted. I sometimes wonder what I would do if I had to make all the materials myself—all of my paints, papers and brushes. If that were the case, I wouldn't bother making art supplies: I'd simply grab some red and black clay and retire to a cave to paint!

When I was very young, maybe six or seven years old, I didn't have nearly the number of clean sheets of paper and pencils that I wanted for drawing. The few supplies I did have didn't last long in my hands—and neither did my siblings' supplies. Often I resorted to drawing in the dusty ground with a stick.

One childhood incident still makes me smile. I obtained some white chalk and was quite excited to have it in my possession. I couldn't wait to draw on a nicer surface than the dirt, and I found the perfect "canvas"— an exterior cement wall of my parents' house. It was clean and smooth and practically begging for some decoration. My bright idea was that a little art would make my mom happy; I could picture her ear-to-ear smile as I was drawing. I also thought about how everyone who walked by would enjoy it.

I spent all day drawing on that side of the house, waiting for my mom to get home from work and admire my wonderful creation. Alas! She was surprised all right, but with horror! I spent all evening and the following day erasing everything I had created with a scrub brush and bucket of water.

I had one thing right, though: When you find a product that suits you, don't hesitate to use it. All art supplies are tools that can help you create wonderful artwork. In this chapter, I discuss the basic tools you need to start painting. They won't make your art career successful instantaneously, but good tools will certainly ease the way.

BABY'S BREATH
25" × 39" (64cm × 99cm)
200-lb. (420gsm) cold-press Arches

Watercolor Paints

Beautiful paints are available from many different companies. Deciding which colors best suit you and your work takes time—experience will make you more confident with your choices. Try out as many colors as possible, but use them selectively to create the mood you want for each painting. I cannot emphasize enough that you learn to *feel* the colors instead of academically applying them. The colors on your palette should act through you to make your paintings. Don't be afraid of mistakes when mixing colors, even muddy mistakes. Trial and error is the best way to get a feel for how color works.

Color can bring out many characteristics in a painting. It creates mood and conveys emotion. It also can establish the light and dark values of the painting.

Many different companies produce watercolor paints, and each company's colors have unique characteristics. Even colors with the same name, such as Hooker's Green, vary from company to company.

I prefer to buy paints with good lightfast ratings, meaning their colors stand up well to the test of time. To find this information, I usually consult *The Wilcox Guide to the Best Watercolor Paints*. Paints that have the best lightfast ratings don't have the most brilliant colors, but I prefer them because the color will last longer.

Also, it's usually best to invest in professional-grade paints instead of the less expensive student- or academy-grade paints. The professional-grade pigments tend to be of finer quality and will produce cleaner and more intense colors than the student grades. Using these finer quality paints will give you better results in your paintings. Even if you're a beginner, they're worth the extra cost. A tube of paint will last quite long, even if you paint every day.

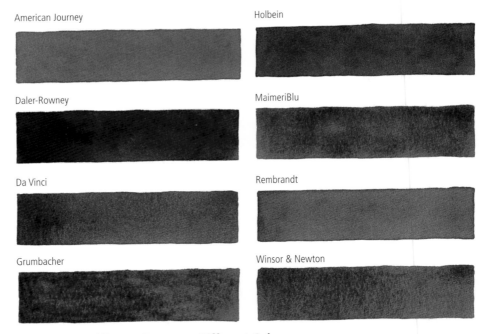

American Journey • Holbein • Daler-Rowney • MaimeriBlu • Da Vinci • Rembrandt • Grumbacher • Winsor & Newton

Same Name, Different Company, Different Colors

It can be confusing, but a color from one company will be different from a color with the same name from a different company. This difference may be subtle or dramatic, so be careful. For example, Hooker's Green paints from different companies show different shades and saturations. As you gain experience, you'll develop a preference for colors manufactured by certain companies.

Water to Pigment Relationship

When you understand how watercolor pigment works with water, painting becomes less stressful and more exciting. Think of water as the boss and watercolor pigments as obedient servants, submissive to the water. You don't have to use a brush to physically mix and mingle water and pigment. Simply drop the pigment onto wet paper and the magic happens—the water tells the pigment exactly where to go!

Pigment Follows Water

Pigment will always follow water. To illustrate this, paint a swirl with clean water. Drop one color into the center of the swirl and a different color onto the end of the swirl. Then, tilt your plywood board back and forth until the pigments mingle as they follow the wetted area of the paper. Water does all the mixing and mingling. No brushwork is necessary to make this swirl. Notice the pigment follows only where you applied water at the beginning of the exercise.

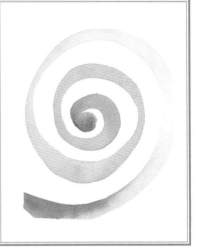

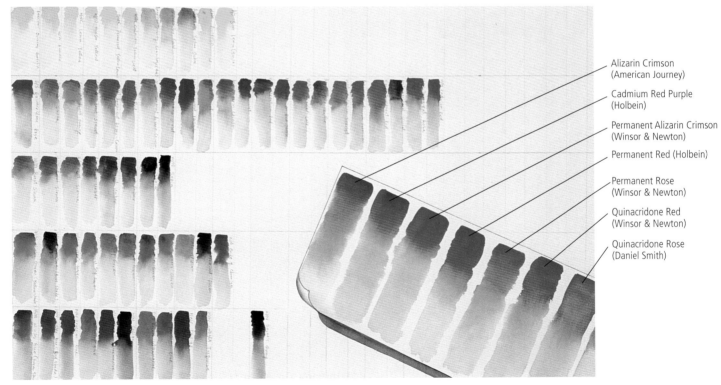

Alizarin Crimson
(American Journey)

Cadmium Red Purple
(Holbein)

Permanent Alizarin Crimson
(Winsor & Newton)

Permanent Red (Holbein)

Permanent Rose
(Winsor & Newton)

Quinacridone Red
(Winsor & Newton)

Quinacridone Rose
(Daniel Smith)

Personal Color Chart

Make yourself a personal color chart like this one to help you see the subtle differences in similar colors. Whenever you purchase a new paint, add it to your chart.

Wet a no. 8 round and remove any excess water. Take some pigment from the tube by actually dipping the brush into your tube, and create the right consistency by dabbing it on the palette. This serves the purpose of checking the pigment's color before applying it to your chart. Use your loaded brush to fill that color's designated space on the color chart. Do this for each color on your palette.

When painting these strips of color, be sure to have one end heavily diluted and the other much less so. This way, when you start thinking about a color's value, you can consult your color chart to see the paint's range of light to dark.

Paint Qualities

The qualities of the paints you choose will affect your work almost as much as the colors themselves.

Transparent vs. Opaque Pigment

Transparent pigment is color through which the paper or underlying layers of paint can be seen. This greatly affects the look of a painting. Light is able to pass through the transparent glazes and bounce off the white of the paper, allowing you to see multiple colors at once. For example, with a first layer of yellow and a second of blue, the resulting color is a beautiful luminescent green. Glazing transparent colors can create a variety of values and hues.

Opaque pigments are paints that, when applied, you can't see through. They have varying degrees of opacity, from semiopaque to completely opaque. You will notice that opaque colors have a slightly chalky texture when you mix them with water on the palette. Those noticeably chalky granules are what obstruct light's penetration to the paper's surface. Light bounces off the surface of the pigment, not the paper. All you will see is the opaque color.

Opaque colors feel heavier and thicker on the surface of your paper. Incorporate them into your painting to make transparent colors appear more vivid, to cover up minor mistakes or for final touch-ups and details.

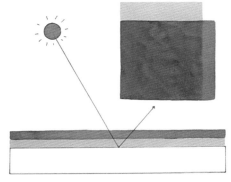

transparent color

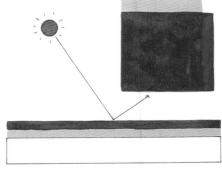

opaque color

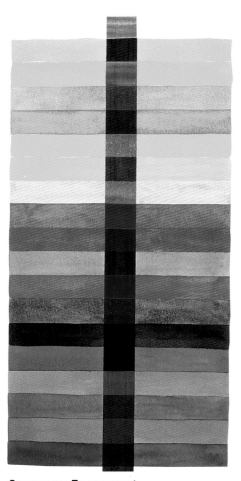

Titanium White (Winsor & Newton)

Aureolin (Winsor & Newton)

Cadmium Yellow Light (Holbein)

Yellow Ochre (Sennelier)

Quinacridone Gold (Winsor & Newton)

Sour Lemon (American Journey)

Winsor Yellow (Winsor & Newton)

Brilliant Pink (Holbein)

Cadmium Red Purple (Holbein)

Quinacridone Rose (Daniel Smith)

Rose Madder Genuine (Winsor & Newton)

Scarlet Lake (Winsor & Newton)

Burnt Umber (American Journey)

Sepia (Winsor & Newton)

Permanent Sap Green (Winsor & Newton)

Cinereous Blue (Sennelier)

Cobalt Blue (Holbein)

Cobalt Turquoise (Winsor & Newton)

Winsor Blue (Winsor & Newton)

Opaque vs. Transparent
Here's a method of testing a color for opacity or transparency. Draw a solid, vertical half-inch black line with a permanent magic marker in the center of a piece of paper. Paint a horizontal, solid block of the color you want to test across the black line. Opaque colors leave a white residue on the black area after they dry. If the color intensifies the marker without leaving a white residue, it is transparent.

Aureolin
(Winsor & Newton)

Quinacridone
Red (Winsor
& Newton)

Winsor Blue
(red shade)
(Winsor &
Newton)

Lemon Yellow
(Holbein)

Cadmium
Red (Winsor
& Newton)

Cobalt
Turquoise
(Winsor &
Newton)

Transparent Color Mixing

Overall, transparent mixed colors are lighter and sharper than opaque mixed colors. They feel delicate, clean and subtle and are perfect for glazing. Transparent colors will not muddy up the glaze.

Opaque Color Mixing

Mixing opaque colors results in beautiful, clean color, but creates a heavier, more intense look. Opaque colors are not ideal for glazing—the chalky pigments will lift off when you glaze over them with different colors. Also, be careful when you mix more than three hues. This increases the chance that you will make a muddy, dull, low-intensity color.

Staining vs. Nonstaining

Some pigments are made up of colorants that actually bond with the paper, making them harder to remove. These are referred to as *staining colors*. Staining colors leave a visible residue if you try to scrub them off your paper. They are particularly good for mixing dark colors.

Many nonstaining colors have opaque characteristics to a greater or lesser degree, but they will not react with the paper—nonstaining paints simply leave a coating. These colors are very easily removed from a painting. Even staining color, however, lifts off the paper's surface with harsh scrubbing.

Try not to scrub too much; even if it's nonstaining paint, the surface might be disturbed or torn. Paint applied to paper that's been overscrubbed never looks quite right, especially on the lighter areas of your paintings.

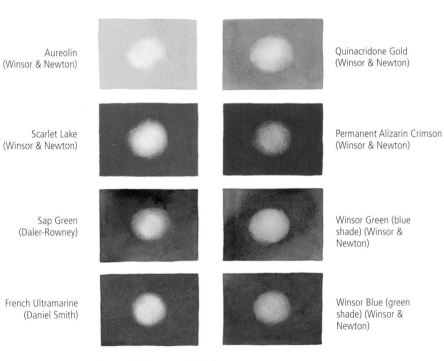

Aureolin
(Winsor & Newton)

Quinacridone Gold
(Winsor & Newton)

Scarlet Lake
(Winsor & Newton)

Permanent Alizarin Crimson
(Winsor & Newton)

Sap Green
(Daler-Rowney)

Winsor Green (blue
shade) (Winsor &
Newton)

French Ultramarine
(Daniel Smith)

Winsor Blue (green
shade) (Winsor &
Newton)

Nonstaining vs. Staining

Some pigments actually bond to paper (staining), while others simply leave a coat of color (nonstaining).

Paint Characteristics

Different paintings have different color needs, so in addition to your main palette with the colors you use most frequently, it helps to have secondary palettes for those colors you need but use less often. To avoid getting into a rut with your colors, ask other artists what they use and try them out. If you own colors that are not listed here, experiment with them on your own to understand and use them to your best advantage.

Yellows

Aureolin (Winsor & Newton)—semitransparent, warm, delicate, good for a first wash because of its tendency toward transparency, widely used for every occasion.

Cadmium Yellow Deep (Daler-Rowney)—opaque, nonstaining, brilliant yellow, an excellent yellow for mixing with any red hue to produce intense orange.

Gamboge (American Journey)—transparent, staining, warm, excellent for the base color of earth hues.

Lemon Yellow (Holbein)—opaque, nonstaining, cool, good for last-minute touching up or covering up mistakes, not recommended for washing.

Quinacridone Gold (Winsor & Newton)—transparent, staining, warm, easy to use right out of the tube; also can be made manually with a mixture of Aureolin, Burnt Sienna and a little Permanent Alizarin Crimson.

Reds

Cadmium Red Purple (Holbein)—transparent, staining, dark and rich red, mixes well with all colors for richness; also can be made manually with a mixture of Permanent Alizarin Crimson, Sepia and Scarlet Lake.

Permanent Alizarin Crimson (Winsor & Newton)—transparent, staining, cool, rich and dark red, good for warm darkest dark when mixed with complementary colors such as Winsor Green or Bamboo Green.

Quinacridone Burnt Orange (Daniel Smith)—transparent, nonstaining, beautiful color right out of the tube, mixes well with every color for richness; also can be made from palette of Quinacridone Red, Burnt Sienna and Gamboge.

Quinacridone Red (Winsor & Newton)—transparent, staining, warm.

Scarlet Lake (Winsor & Newton)—opaque, nonstaining, warm, good local color for dark red flower petals and red subject matter.

Browns

Burnt Sienna (Winsor & Newton)—transparent, earth color, staining, warm, mixes well with all colors.

Burnt Umber (Winsor & Newton)—transparent, earth color, staining, warm; mixes well and enriches greens, yellows and reds.

Sepia (Holbein)—transparent, dark earth color, warm, staining, darkest dark value for shaded areas when mixed with Winsor Green and Permanent Alizarin Crimson, creates various colors when mixed with Sap Green.

Violet

Quinacridone Violet (Daniel Smith)—transparent, staining, cool, delicate, mixes well with red and blue; produces a delicate gray when mixed with Gamboge, Quinacridone Gold and Aureolin.

Greens

Bamboo Green (Holbein)—transparent, staining, brilliant green containing yellow; warm, clean and dark shade good for mixing with complementary colors.

Sap Green (American Journey)—transparent, staining, warm, soft and pale green, super right out of the tube; also can be made manually with a mixture of Hooker's Green, Burnt Sienna and a touch of Permanent Alizarin Crimson.

Hooker's Green (Winsor & Newton)—transparent, staining, warm, beautiful when used by itself.

Winsor Green (blue shade) (Winsor & Newton)—transparent, staining, cool, rarely used by itself because the color looks artificial and neon (intense), excellent for mixing with complementary reds.

Blues

French Ultramarine (Winsor & Newton)—transparent, semi-staining, warm.

Indigo (Holbein)—transparent, staining, warm, used for deep and dark blue, excellent for making the darkest dark shades.

Prussian Blue (Daler-Rowney)—transparent, staining, cool, good all-purpose blue.

Winsor Blue (green shade) (Winsor & Newton)—transparent, staining, cool, very intense, excellent for mixing.

Palettes

Once you've experimented with different paints, outfit your main palette with the colors you find yourself using the most. Setting up your palette can be a very personal matter, but it is best to arrange the colors into meaningful groups. As with my palette below, start with your yellow hues, then add your red hues, earth tones, green hues and blue hues. Grouping your palette by hue makes it easier to mix the exact color you want. However you choose to set it up, remember it's the colors that really matter.

Before you start to paint, squeeze only as much color from the tube as you will need for your current painting session. Work with fresh colors on your palette every time you paint—unused paint is easier on your soft brushes and will help the tips last longer. Also, dried out pigments can lose intensity and sometimes become gummy or grainy.

The pure pigments lingering underneath your mixtures will harden overnight or over several days. To resurrect these dried-out colors, simply run the palette under a faucet to rinse off the previously mixed colors on top. Gentle, slow running water will leave the partially hardened, pure paint on the palette. After rinsing, let it sit for awhile before starting to paint—the leftover water will soften the hardened pigment. If more colors are needed at this point, add fresh pigment to your palette.

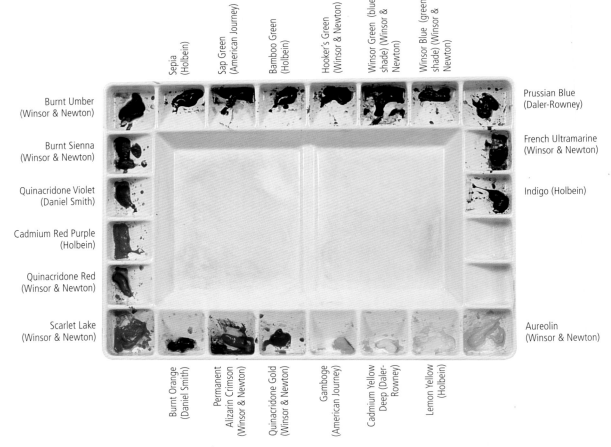

Coordinate Your Colors
It can help to arrange your colors in this order: yellow, red, earth color, green and blue. Notice the cool colors, green and blue, and warm colors, yellow and red, are on opposite sides of the palette to prevent accidental mingling. The earth colors are between the warm and cool colors. This arrangement of colors on your palette gives you the freedom to mix slightly different colors right next to your primary hues while painting.

Paper

Many different companies make water-color paper in a variety of weights, such as 90-lb. (190gsm), 140-lb. (300gsm), 200-lb. (425gsm), 300-lb. (640gsm) and heavier. When referring to paper, "weight" means the weight in pounds for a 500-page ream of 22" × 30" (56cm × 76cm) sheets.

The size of watercolor paper is generally consistent from company to company. A full sheet is 22" × 30" (56cm × 76cm). You can make half sheets yourself by cutting a full sheet into two 22" × 15" (56cm × 38cm) pieces.

There are also "blocks" of watercolor paper with all four sides of the paper glued together. These are available in many different sizes. When you finish with the top sheet, simply peel it from the block. Unfortunately, you lose the deckled edges when using paper blocks. If you want sizes larger than 22" × 30" (56cm × 76cm) full sheets, you can find 29" × 41" (74cm × 104cm), 40" × 60" (102cm × 152cm) and 44.3" × 10" (113cm × 25cm) yard rolls.

Choosing types of paper is a personal preference. Get paper samples of each variety and test them to find the surface you like best.

Hot Press
Hot-pressed paper is smooth and slick. It's good for very fine detail, but not suited for multiple glazes. The pigment doesn't always soak into the paper, so your previous layer may lift when you apply another.

Cold Press
Cold-pressed paper has a medium texture—not too slick, not too bumpy. It accepts many glazes without the previous layer lifting. Cold-pressed paper is preferable for rich and vibrant paintings, because it's smooth enough for details but rough enough to absorb plenty of water and color.

Rough Press
Rough-pressed paper is bumpy and has a rougher texture. It will absorb a large amount of water and color beautifully and is good for bold, large subject matter that doesn't require tremendous detail.

Stretch Your Paper

Applying water to dry paper will cause the paper to buckle. Buckling will make washes uneven and can prevent you from seeing the harmony of the whole picture. It takes a little time and effort, but stretching is a worthwhile process, especially when you're using paper lighter than 200 lbs. (425gsm).

Wet your paper completely. Put the paper in a bathtub and allow it to float freely. Allow 140-lb. (300gsm) paper to float for about 10 to 20 minutes. Leave 300-lb. (640gsm) paper for 20 to 30 minutes. Usually 300-lb. (640gsm) paper doesn't have to soak and stretch. It's heavy enough to stand up to washing and painting without much buckling, though the edges may curl.

Brushes

Brushes are a vital tool for artists, and choosing the right ones will make your painting process easier, cleaner and faster. When covering a larger space, use a bigger brush; it will help you cover the area quickly. For smaller areas, use smaller brushes; these make corners and details easier to handle.

I used to buy high-quality calligraphy brushes whenever I visited Korea. I like them because they hold a lot of water and have pointy tips that last a long time. I also like Kolinsky sable brushes, but they're expensive. I no longer need to buy the Korean brushes, however: I've recently dicovered a more economical line, Silver's Black Velvet brushes, that I love and recommend to everyone. I bought several of them in different sizes.

However, the old calligraphy brushes are still useful. Nos. 6 and 8 rounds are good for drybrushing, and nos. 12 and 16 are good for applying washes to large areas, such as backgrounds.

You can usually use a no. 4 round for very fine detail, nos. 6 and 8 for mid-sized detail and layering color, and nos. 10 and 12 for larger details. Use worn-out, dull calligraphy brushes, such as a no. 16 round, to load pigment or water onto larger spaces. A script liner brush is very useful for thin and long lines, such as the veins in flower petals or leaves.

Try different kinds of tools and brushes until you find the ones that best suit you and your paintings.

Several old bristle brushes for scrubbing (any brand)

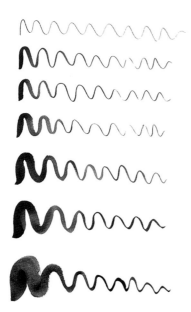

Different sizes of brushstrokes

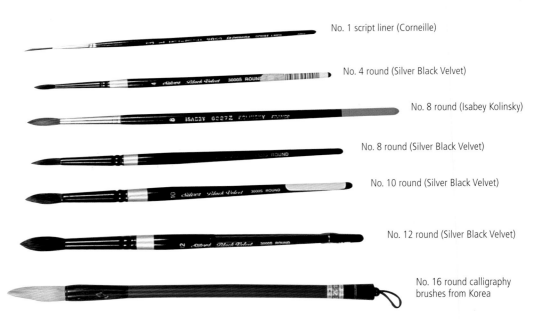

No. 1 script liner (Corneille)

No. 4 round (Silver Black Velvet)

No. 8 round (Isabey Kolinsky)

No. 8 round (Silver Black Velvet)

No. 10 round (Silver Black Velvet)

No. 12 round (Silver Black Velvet)

No. 16 round calligraphy brushes from Korea

Adding Acrylics and Gold Powder

When using multiple watercolor washes to create deep and saturated color, applying a layer of liquid acrylic paint helps the previous watercolor layers stay on the paper. After applying several layers of watercolor washes, the paint tends to lift off when you apply clean water and color for the next layer. Applying a liquid acrylic wash minimizes the tendency of previous layers of color to lift.

Add acrylic layers sparingly, however, because overuse tends to produce a slick, waterproof surface that makes finishing the painting with watercolors difficult. If you choose to use many acrylic washes, be sure to save the areas that will need later applications of watercolor with masking fluid.

I prefer using the fluid acrylics from Golden. The liquid consistency of the paint makes the preparation of the color simple—just thin it with water as needed. All the colors you could want are available from Golden. However, as always, experiment with many different brands before deciding what works best for you.

Brushes for Acrylics

Use the same hake brushes that you use for applying watercolor washes to apply acrylic paint. However, be sure to wash the brushes with a little dish detergent as soon as possible after the final step before the acrylic paint dries out and ruins your brush!

Using Gold Powder

You can incorporate a mixture of gold powder and acrylic medium into your watercolor paintings to revive a lost highlight within a dark area. Using gold powder can also make your composition more interesting by creating fun patterns and shapes in an otherwise flat, boring background. However, keep in mind that, after applying the gold powder and acrylic medium mixture, the area becomes waterproof.

The gold powder needs a binding medium to ensure that it won't flake off when it dries. Golden acrylic medium is what I prefer, mixed equal parts medium and water and with the gold powder added.

Brushes for Gold Powder

Use the same no. 1 or 2 script liner brushes for the lines and patterns as you use with watercolor paints. Be sure to rinse the brush with dish detergent from time to time if the process of painting with the gold mixture takes much more than an hour. You don't want the acrylic mediums to dry in your brush.

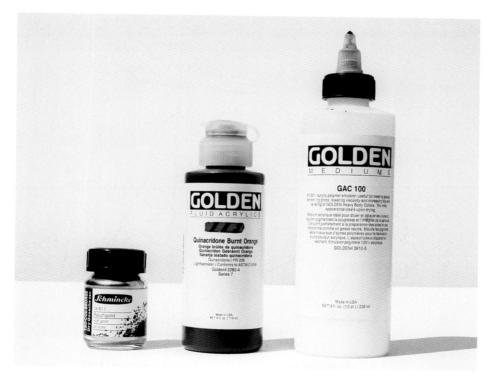

Acrylic Paint and Medium and Gold Powder

Incoporating washes of acrylic paint between layers of watercolor will help keep the watercolor in place as more washes are added. Using a mixture of water, acrylic medium and gold powder is a good way to lighten dark areas of a painting.

Other Materials

Here are a few more tools every artist should have on hand.

Pencils

For drawing, use a mechanical pencil with 0.5mm H or B graphite. This lead is soft enough not to make scratches on the paper but dark enough so you can easily see your drawing. For transferring drawings onto watercolor paper, use 5B to 6B pencils for darker, softer effects.

Erasers

The Design Kneaded Rubber eraser from Sanford is good for general erasing on watercolor paper. The gummy texture will not scratch or buff the paper. Mars Plastic erasers from Staedtler are a good choice for erasing the sketch after finishing a painting. They are a little harder than rubber erasers and are better for thoroughly eradicating pencil lines.

Tracing Paper

Tracing paper is transparent and sleek. Drawing directly onto it will make transferring your drawings to watercolor paper a snap. Tracing paper withstands lots of erasing.

Masking Fluid

It's not easy to save white lines or spots for highlights when painting watercolor, especially during the washing process. Masking fluid can save you time and enhance the fluency of your painting (see page 46 for more details).

Different companies call this product different names. Grumbacher calls it Miskit Liquid Frisket, Winsor & Newton calls it Art Masking Fluid and Grafix uses the name Incredible White Mask.

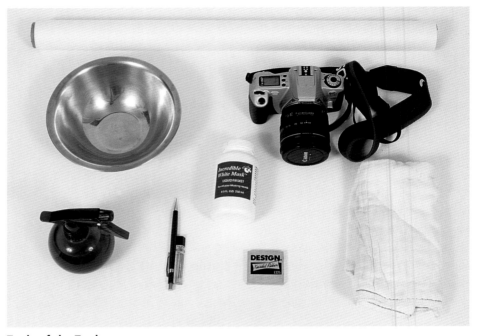

Tools of the Trade

Don't use your good brushes to apply masking fluid—it dries on the brush and won't clean out. Instead, use a toothpick.

Remove masking fluid after a painting is completely dry with rubber cement pickup. To find leftover masking fluid (it's not easily visible), run a freshly washed hand over the painting. Masking fluid is sticky, so you'll feel it right away.

Water Bowl

Stainless steel mixing bowls work great for holding water. They're unbreakable, dishwasher safe, nonstaining, and have a smooth rim that gently removes excess water from your brushes. Have several bowls of water on hand as you paint. Once the first water bowl is full of pigment, switch to the next. This way, you won't have to keep running to the sink for clean water and interrupting your concentration.

Cotton Rag

Use 100 percent cotton cloths for your rags. Softer is better. Cotton rags absorb plenty of water and are practical and inexpensive (as well as machine washable). Paper towels work well, too, but can be very costly. Instead, try recycling household items, such as old undershirts or cloth diapers.

Spray Bottle

Any bottle that sprays a fine mist will work wonderfully for wetting large areas of your paper.

Camera

Use any camera that will sufficiently capture the images you like to paint. Use an automatic SRL camera for quick point-and-shoot shots. An SRL manual camera with a macro lens is ideal for capturing details and photographing still-life arrangements.

Where to Work

My husband tells people we don't have a home-based business—we have a business-based home! Our living room is my studio. The room has a large easel, a medium easel and three large tables for painting, reading, sketching and drawing. Works in various states of progress adorn our dining room table. We've reserved all the wall space for completed paintings. One guest bedroom is used as a framing room and has huge flat drawers for new watercolor paper; the other spare room serves as storage space for other materials. Boxes for shipping paintings and unused frames have taken over our garage closets. It is wonderful and lucky for me that my husband is a very understanding and tolerant person.

I like working in my home-based studio, but it has its advantages and disadvantages. Some of the advantages of having a home studio are that I can start working whenever I feel like it; my husband and I stay in the same room and communicate when I'm painting in the evening; and I don't feel guilty about retiring to a separate room to work. The main disadvantage of having a home studio is that our home doesn't look like the showcase it could be. The positives outweigh the negatives, so I don't want to move my studio somewhere else.

The west side of my studio is all glass with sliding doors, so I get plenty of light during the day. I also have floor lamps to use if I need extra light. I use a halogen lamp and/or a fluorescent lamp on rainy days. I don't need daylight bulbs or other special lighting. I don't paint pale-colored paintings, so washing out a little red with fluorescent light is not a major issue for me. I also have very nice views of my backyard gardens through all the glass.

Where you paint—fancy or not—does not need to be a factor in your painting. How much you desire to paint and put your hands to work is all that matters. You can claim a small corner of the kitchen table, dining room table, living room coffee table or even the floor as a working place.

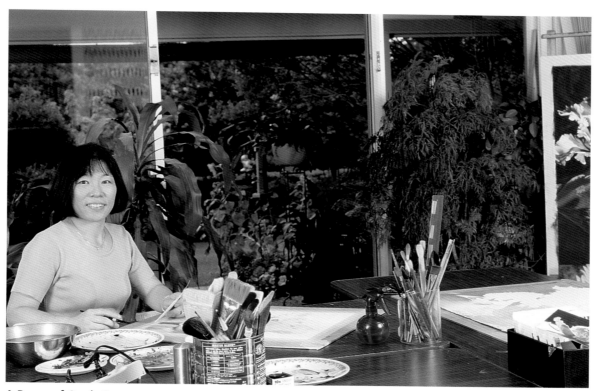

A Room of One's Own
This is my living room/studio. However, the important thing about painting is not where you're doing it, but that you're doing it.

Art and Color Theory

Color is a product of light. With watercolor, you see the colors reflected by pigments rather than properties of the pigments themselves. Color varies depending on the surroundings and circumstances; these variations make our visual experiences interesting.

Do you need to understand the physics of colors? Do you really want to understand color scientifically? Nope! Just play with color to create something you really enjoy, especially when painting flowers. You don't need a full understanding of how light affects objects to re-create natural colors in your paintings.

Each artist has his or her own intuitive way of expressing something with color. Color is one of your most individual elements. In a classroom, everybody paints the same red rose, but each artist portrays it in a different style and with different colors—shaded red, tinted red, purple red or just plain red.

Colors can express emotion, vibrancy, softness, richness, passion, etc. How you use color to provoke viewer response is as individual as you are, but there are basic concepts that can help guide everyone.

MUMS
22" × 15" (56cm × 38cm)
140-lb. (300gsm) cold-press Winsor & Newton

Color Basics

My understanding of color stems from hours and hours of painting. I learned about primary and secondary colors as a child, but I came to know them through experimentation. When I started painting, I didn't know anything about color-naming conventions or paint quality, but I knew *my* paints and how they would respond because I used them all the time. Before I began a painting, I would spurt color onto my palette and use a brush to see how it looked.

By now, of course, I've picked up all kinds of information about my paints and their characteristics, information that I refer to all the time. But it's that personal understanding of color that will guide you and help you feel secure about each new color adventure.

Properties of Color

There are a few terms and concepts you should know to help you better understand color.

Hue is the name of the color produced by a pigment. The term also is used as the name of a paint made as a substitute for another paint. For example, one manufacturer sells Gamboge Hue as a lightfast substitute for its non-lightfast Gamboge.

Value, or tone, is a color's relative lightness or darkness. When speaking about values, "shade" refers to the gradation towards darkness and "tint" refers to gradation towards lightness. Strongly contrasting values, such as black and white, tend to be more visually exciting when placed next to each other in a painting. However, be judicious in your use of contrasting values—they can disrupt the harmony of an image.

Saturation (intensity) is the purity of a color. A higher saturation implies greater color purity.

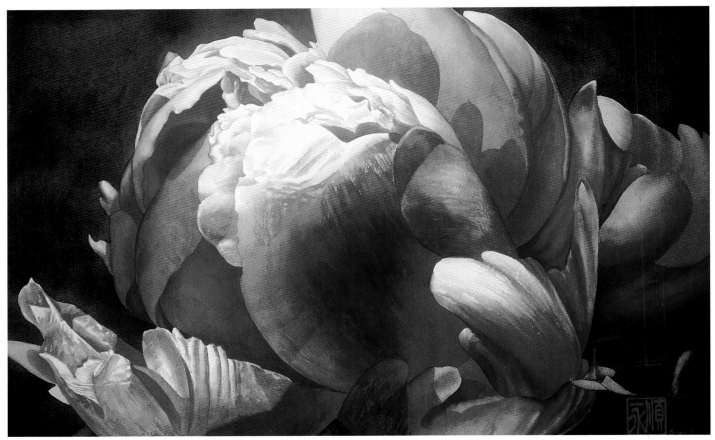

Spotting Hue, Value and Intensity
OPENING DAY (15" × 22" [38cm × 56cm]) is a good example of using different hues, values and intensities. While the flower is all one color, the varied values and intensities create shadows, depth and three-dimensions in the painting.

Primary Colors

The primary colors can be combined to create pyramids of yellowish hue (Aureolin; Cadmium Yellow Deep, Medium and Light; Lemon Yellow; etc.), reddish hue (Permanent Red, Cadmium Red, Indian Red, Carmine, etc.), and bluish hue (Cobalt Blue, French Ultramarine, Prussian Blue, Pthalo Blue, etc.). There are no formulas that apply to every situation, so have patience and fun as you experiment and learn. That is how your attitude and personality will begin to come through to make your paintings unique.

Secondary Colors

The secondary colors—green, orange and violet—are the result of mixing two primary colors. They have less intensity (saturation) than the primaries.

Tertiary Colors

Mixing a primary with a secondary color produces a tertiary color. For example, mixing blue and green to get a bluish green; violet and red to produce reddish violet; or orange and yellow to produce yellowish orange. Mixing primaries and secondaries in varying ratios produces a spectrum of tertiary colors—more, in fact, than the naked eye can discern.

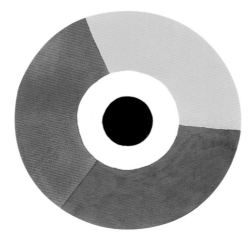

Primary Colors

There are three primary colors: yellow, red and blue. These three colors are pure; they cannot be created by mixing other colors together. If you mix equal parts of all three primaries, you'll produce black, but using two at a time, you can create an endless variety of colors.

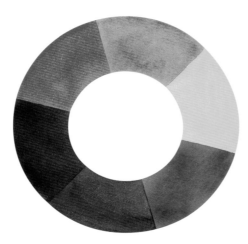

Secondary Colors

Secondary color results from mixing two primary colors. Red mixed with yellow creates orange, red mixed with blue makes violet, and yellow mixed with blue produces green.

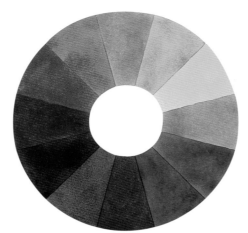

Tertiary Colors

Tertiary color is produced when three or more different colors are combined. You usually will create these by mixing one primary and one adjacent secondary color.

Complementary Colors

You can always tell which colors are complementary because they appear on opposite sides of the color wheel. Orange complements blue, violet complements yellow, and red complements green.

Complementary colors have a love-hate relationship with each other. When they are side by side, they make a brilliant color combination. Mixed together, however, they cancel each other out and make a gray, muted color. You will notice harmonious and monochromatic paintings use very few or no complementary colors. However, using complementary colors will consistently make brilliant, colorful paintings that convey a happy feeling.

The muted grays created by mixing complementary colors are much more interesting and versatile than a simple mix of black and white. The resulting grays will tend to have a warm or cool nature, depending on the colors you mixed. Using these muted colors in the background or in less important areas will help more intense, adjacent colors shine. Also, mixing complementary colors will subdue the dominant, loud color whether you glaze the colors together or lay them side by side. Using complementary colors to make rich darks will keep you from resorting to black, a dreaded, dull color.

Red + Green

Violet + Yellow

Orange + Blue

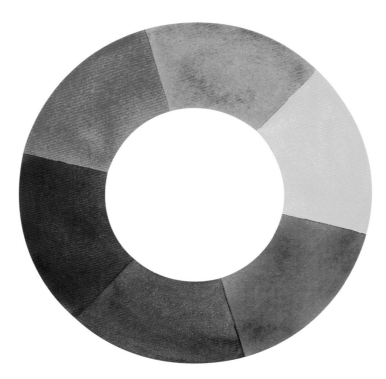

Temperature

Mixing clean and brilliant color is always important, especially when painting in watercolor. You know there are three primary colors—yellow, red and blue—but because there's a warm and a cool of each, you could say that there are really *six* primary colors. These warm and cool variations are a color's temperature.

It may seem that yellow and red are naturally warm colors, while green and blue are naturally cool. To an extent that's true, but each color has warm and cool versions of itself. A cool version of yellow, for example, is Lemon Yellow, and a warm version is Cadmium Yellow Light. Permanent Alizarin Crimson has a cool temperature, and Cadmium Red has a warm temperature. Blue also can be separated into cool colors—like Winsor Blue (green shade)—and warm colors—like Ultramarine Blue.

Temperature Color Wheel

It's important to understand temperature when mixing colors. Mix cool colors only with other cool colors, and warm colors only with other warm colors. To make a clean yellow sunflower, add warm reds and oranges for the darker, shaded areas. Add warmer earth tones for the darkest dark areas with a touch of a complementary color.

Some companies make versions of the same color at different temperatures. These colors are always clearly labeled. For instance, Winsor & Newton makes two types of Winsor Blue, a warmer red shade and a cooler green shade. The companies also makes Winsor Green in both a warmer yellow shade and a cooler blue shade.

Effects of Temperature

Optically, warm colors such as red, orange and yellow seem to advance toward you, while cool colors like blue, green and blue-violet recede. Use cool colors in shaded areas to create the illusion of receding. This plays an especially large role in representational painting.

Psychologically, warm colors inspire cheerful, happy and positive feelings, while cool colors express calm, serene and quiet feelings, maybe even mild depression.

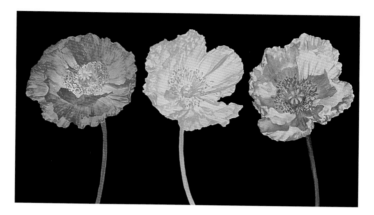

Optical Illusions
Warm colors come forward and cool colors recede. Squinting your eyes can make this illusion clearer.

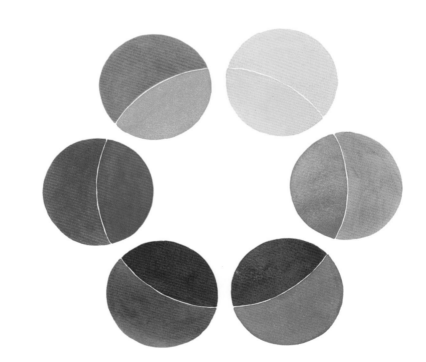

Six Pigment Color Wheel
In a six-color wheel, the colors on the inside of the circle are warmer versions of a color than those on the outside. Still, the yellow, orange and red side has dominantly warmer temperatures than the other half.

Value

Value is the relative lightness and darkness of a color. A greater amount of reflected light results in a higher value, while less reflected light produces a lower value. For example, white, the lightest value, reflects a lot of light while black, the darkest value, absorbs a lot of light.

Value vs. Color

Remember that color is not the same thing as value. Black and white photos and other value-study tools, such as red acetate, reduce images to values only. For instance, a dark blue or red may appear black in a black and white photo. Yellows, on the other hand, have an inherently light value and will never appear as dark as black. In watercolor, lighter values are created by diluting a pigment. This allows the lighter value of the white paper to shine through. Use these diluted pigments for lighter areas and thicker pigments for darker areas.

Value and Contrast

High value contrast is a good way to emphasize elements of a subject for visual impact. Even a small white element will get attention when surrounded by darker values, and vice versa. This exaggeration of light and dark can turn an ordinary painting into an extra-special one.

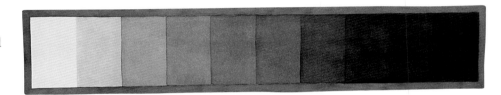

Value Scale
Here is a 10-point value scale that you can create yourself. I used a complementary gray made from Hooker's Green and Quinacridone Red, but you can paint with any color you like. Add more water to lighten the value.

Despite the fact that the value is the same all the way around the rectangle, the outer line on the right side looks lighter than it does on the left side. This demonstrates how adjacent values can influence your eyes. Lighter values placed next to darker values and vice versa make each color stand out, as they create contrast.

Tonal Emphasis
In this painting, the pale and light flowers are juxtaposed with an exaggerated dark stem and leaves. The dark surroundings make the light flower stand out—it would be lost in a light background.

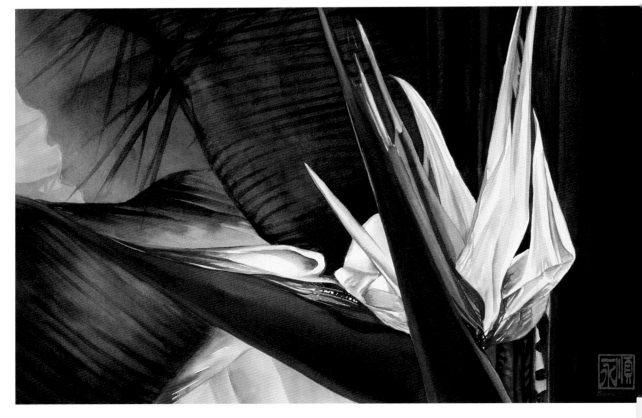

Value and Mood

Creating mood is achieved most effectively by controlling and manipulating value. Value can be used to create feelings from quietness and calmness to eeriness and moodiness. Paintings created using lots of darker values will be more somber and quiet, while paintings that use a majority of lighter values will be happier, brighter and sometimes less serious. Changing the value of a painting can completely change the way a viewer interprets it.

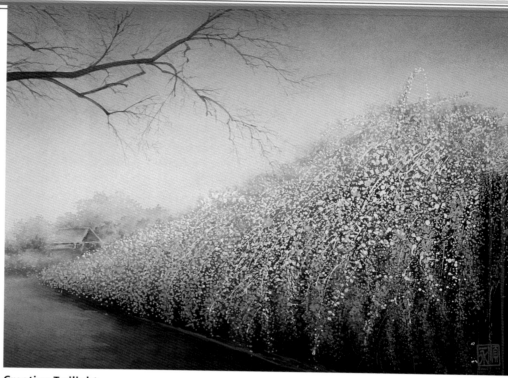

TWILIGHT
22" × 30" (56cm × 76cm)

Creating Twilight
The use of mid to dark values in this painting creates a mood that is quiet and calm. The light is distributed evenly, and the painting doesn't have white highlights—the yellow is the lightest part. This helps establish the value harmony, which in turn creates the somber mood.

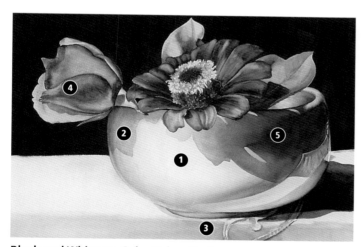

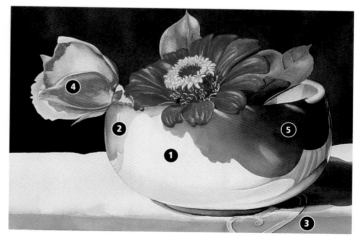

Black and White vs. Color Value Study
Value is much more identifiable in a black and white painting. If you use just one hue, it's easier to spot the dark and light versions. Notice the dark value of the zinnia and the slightly lighter value of the rose. Try to see the relationship of the values in the white bowl, where the range of value is dramatic. The cast shadow of the zinnia creates the darkest value.

1. Lightest highlight (paper white)
2. Light mid-value
3. Mid-value
4. Dark mid-value
5. Darkest dark

Composition

The particular arrangement of visual elements such as lines, spaces, values and colors is what makes your painting an arresting work of art. Use your unique composition to draw the viewer in and move his or her eye around the page.

There are no magic rules to follow that will make a painting's composition exciting and complete—as always, experiment to discover what works for you. However, there are some guidelines that can give you ideas and help you make decisions about the best composition for your painting.

Paper Orientation

First, you have to decide what format to use for the specific subject matter. Generally, you'll choose either the landscape (horizontal) or portrait (vertical) paper orientation. You also can use oblong,

square or diamond formats to make your art stand out.

When you choose your format, keep in mind that you want your subject to cover at least 70 percent of the picture plane. Choose the format that will emphasize your subject without creating an overpowering background. If you're painting a long-stemmed iris, for example, the portrait format will probably work better than the landscape.

Portrait and Landscape
Generally, paper orientation is either portrait (vertical) or landscape (horizontal).

Alternate Paper Orientations
Oblong, square and diamond formats can be used to make your work stand out.

Eye Movement

As you plan your composition, think of how your eyes moved around your reference photo. Where did your eyes linger? What led them there? Unless you have a good reason for doing so, avoid placing your main subject matter in the middle of the composition. That will shorten your viewer's attention span and create a static feeling in the painting. To avoid this, try repeating some of the auxiliary elements throughout the painting or enlarge the main subject to create eye movement.

Creating Movement
The left side dominates this drawing. Using a circular motion creates movement and draws the viewer's eyes through the painting, as well as generating interest and excitement.

Break the Rules

Maybe the most important rule of composition is to break the rules! All guidelines can help you create interesting drawings, but they are not unbendable. Your eye will become trained as you gain experience as an artist. You know how to match your clothes every morning. You know when you like or dislike an interior design. You will learn composition unconsciously from peers and teachers or museums and galleries. Without realizing it, you probably already know a lot more than you think about painting.

Center of Interest

In any painting, you want to give strong emphasis to one spot to grab the viewer's interest. That part of the painting becomes the center of interest (or focal point). The other elements you choose for the design should work to support the focal point, not overpower it. Supporting elements can be sizes, colors, values, placements, directions or many other components.

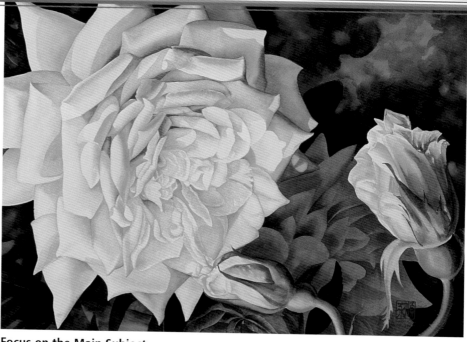

Focus on the Main Subject

In this painting, the focal point is the largest opened rose. The two buds are part of the background and face the main subject, leading the viewer's eyes to the main rose.

YELLOW ROSE
21" × 29" (53cm × 74cm)
140-lb. (300gsm) cold-press Arches

Poor Composition

This simple diagram shows small elements scattered all over the picture plane. This placement looks busy, but doesn't stimulate eye movement or have anything to really grab the viewer's interest. Though the elements are spread out, it feels static.

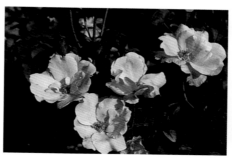

Poor Photo

It's rare that you find a naturally good composition in nature. This photo has the same problem as the above diagram. Try taking more than one reference photo and combining several of them to make the composition more interesting.

Better Photo

This photo has good elements of composition, with a clearly defined focal point and secondary flowers to create eye movement. It needs little or no alteration to make a good reference.

Better Composition

This diagram shows small elements arranged to create a clear, interesting focal point. It doesn't look busy, but has enough elements to move the viewer's eye.

Rhythm and Repetition

To create interesting movement in a composition, repeat the shapes, colors, values, lines and directions of the compositional elements. Repetition makes the rhythmical movement of a painting more pronounced and effective. A variety of similar elements will create a harmonized and balanced design.

Balance

When the subject of your drawing is balanced and situated to your satisfaction, trust your judgment. The balance is probably good. There is no objective way to measure good or bad in a composition, so keep studying the work of others and train your eye to see the interesting relationships between elements. Since there are no guidelines or rules that will magically produce the paintings you want to make, try different techniques and look at as much art as you can to learn what suits your style.

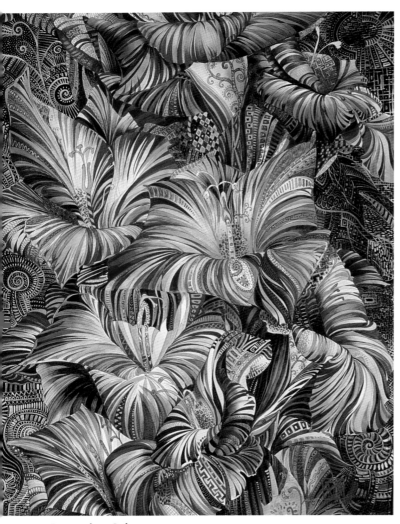

Repeating Colors

The repetition of shapes and colors in PATTERNS OF LINES creates a feeling of harmony throughout the painting, and the lines and the subject bleeding off the page create movement.

PATTERNS OF LINES
22" × 30" (56cm × 76cm)

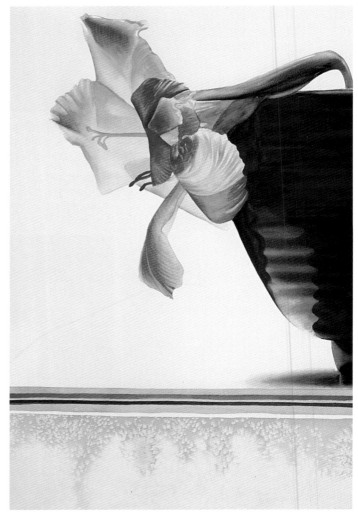

Balancing Act

The leaning gladiolus in this painting needed more balance to look stable, so I placed several lines under the bowl. In addition to establishing the balance, the lines incorporate more of the flower's color into the background.

GLADIOLUS AND BLUE BOWL
15" × 22" (38cm × 56cm)
140-lb. (300gsm) cold-press Arches

Breaking Up the Background

You will sometimes work with a single compositional element, such as a lone blossom. Since this is the obvious center of interest with no distractions, the viewer's attention will not be diverted. Placing a single blossom is simple, but creating an interesting, exciting design around it depends on your placement of supporting elements.

Try breaking up the background behind a single compositional element with a natural setting of leaves, utilizing color, pattern, value, textures and so on. This will help your eyes move around better than they would with a solid background, which lacks movement.

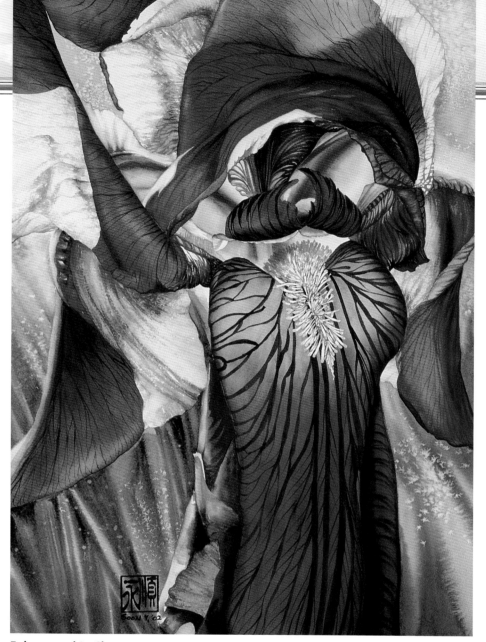

Stopping Static
Place your subject in the center, then break up the background with different values of the same color.

Enlarge and In Charge
Bleeding the subject out of the picture plane creates movement.

DANCING IRIS
15" × 22" (38cm × 56cm)
200-lb. (425gsm) cold-press Waterford

All the World's a Stage

Painting is theater, and blank watercolor paper is your stage. Clean and sharp colors are lead actors, and muted and grayed colors are the supporting cast. Brushes, water and pencils are costumes and sets. You are the director!

Every actor (color) plays a different role. The lead actors (bright and clean colors) lead the show (painting) most of the time, while supporting actors (muted and grayed colors) play parts to support the story. All the actors are important to the show's overall effect and have their own, individual personality traits. The supporting actors will make your story flow more smoothly and logically and help to make the main actors shine.

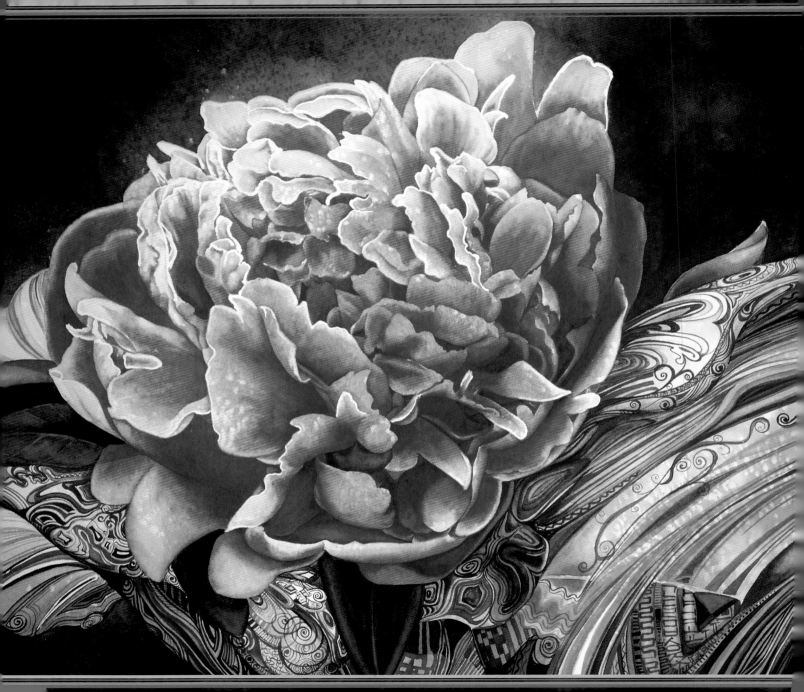

Watercolor Tips & Techniques

When I was growing up, my basic medium was a no. 2 pencil. I would fill up all the empty space in notebooks, textbooks and anywhere else I could fit my scribbles. I drew a lot of cartoon characters and decorated the backgrounds with flowers. I used my pencil to draw flowers and leaves over and over, memorizing their names.

I always wondered how to add color to my scribblings, and when I discovered Cray-Pas (which are similar to crayons), I was fascinated by the possibilities. I was finally able to render red roses and yellow daisies. Making the transition from black and white to color was impressive, and I was very proud. My appreciation of color still grows every day of my artistic life.

At first, creating a three-dimensional work on a two-dimensional surface was mysterious and magical to me. As a young girl, whenever I had free time I went to an artist's studio to see how they made this magic happen, and I practiced and practiced to see if I could mimic it. Over the years, I've learned many techniques through observation and practice, trial and error. I share some of them with you here.

When you have passion for something, plunge yourself into it. As time goes by, the struggles you experience now in your art will become fond memories of your journey. Hopefully, I can help to alleviate some of these struggles and ease your journey with the techniques I have polished through many years of watercolor painting.

PEONY AND GREEN
15" × 22" (38cm × 56cm)
140-lb. (300gsm) cold-press Winsor & Newton

Mingling Colors

I can't emphasize enough how important the layering process is for watercolorists. Layering different colors results in brilliant and unexpected hues and brings life to your two-dimensional, white surfaces.

As with all painting techniques there are some general guidelines to follow, but experimentation and innovation will reveal your unique style. Use different colors with as many layers as possible to create something out of the ordinary.

Layering starts with your basic wash and is followed by two different techniques to mingle color: glazing and charging.

Basic Wash

The very first drop of color to hit your paper is the beginning of your basic wash. Use this first layer to establish your base color and values for the finished work. It can be as rough or detailed as you like, but apply your basic wash with your end result in mind—what will it look like with other colors on top of it?

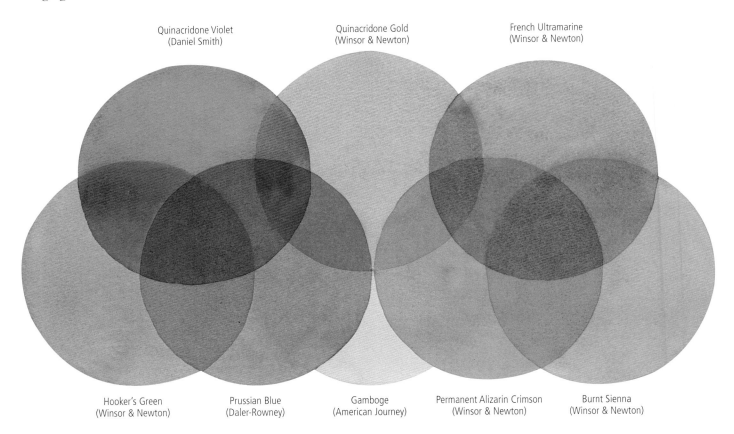

Quinacridone Violet
(Daniel Smith)

Quinacridone Gold
(Winsor & Newton)

French Ultramarine
(Winsor & Newton)

Hooker's Green
(Winsor & Newton)

Prussian Blue
(Daler-Rowney)

Gamboge
(American Journey)

Permanent Alizarin Crimson
(Winsor & Newton)

Burnt Sienna
(Winsor & Newton)

Basic Layering
This is a very simple example of layering. Notice how the various colors meld to create different hues.

Flat Wash

It's important to use the largest brush you can in the space allotted for the wash. Starting with the largest area to be covered, apply color with your fully loaded brush, being careful to leave a puddle of pigment after each stroke. Pull this excess pigment from the wet edge to the unpainted areas. When you are finished, dab your brush on a rag to remove excess pigment and use the dried brush to soak up the puddle at the end of the wash to prevent runback.

Gradated Wash

A gradated wash gradually gets lighter as it moves down the page. At the point on the page where you want it to begin lightening, leave the puddle from the previous brushstroke and dip your brush in clean water. Dab off the excess and pull the puddled pigment downward. While you're doing this, it's helpful to keep your paper tilted at a 15-degree angle, which will prevent the diluted pigment from running into a darker area and creating a blossom.

Multiple Wash

Use a 2-inch (51mm) or 3½-inch (89mm) hake for the larger areas and a no. 12 round for smaller areas to create a smooth multicolored background wash. Apply Aureolin to wet paper, and after it dries, rewet it. Using the same brush, apply a gradated wash of Permanent Alizarin Crimson. When this wash dries, apply Prussian Blue anywhere a darker effect is desired.

Combining Washes for a Multicolored Effect

Layering multicolored, gradated washes of different colors creates contrast in the background. The main subject matter, the peony, emerges from within the gradated background rather than appearing separate from it. The glass incorporates several colors used throughout the painting, which helps harmonize the work and unite the subject and background.

PEONY IN GLASS

15" × 22" (38cm × 56cm)
140-lb. (300gsm) cold-press Winsor & Newton

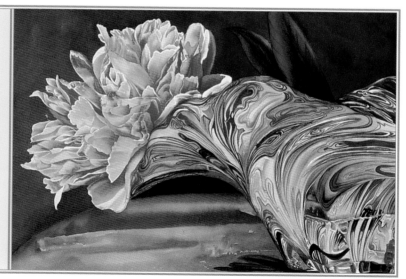

Glazing

Glazing is the application of thin pigment over existing layers of color. It can create extraordinary color and help establish the necessary values. There is no limit to the number of layers you can apply, but note that as the pigment gets thicker and heavier on the paper, previous layers will lift off easily.

The most important thing to remember when glazing is to wait for the previous layer to dry before applying the subsequent glaze. Glazing while a layer is still wet can result in mishaps like blossoms or backruns. Try starting with one color and working your way to different colors to get a feel for the effects they will have.

Tube Colors vs. Glazing
Using Hooker's Green out of the tube (left) makes this leaf look fresh and sharp, but it lacks the dark intensity of the leaf created by glazing (right). To achieve this realistic green, paint the leaf in Gamboge then glaze on several layers of Winsor Blue.

Glazing Pros and Cons

Advantages:
* Accurate rendering with better control
* Produces a stronger, darker pigment with minimum layers
* Easy manipulation of edges

Disadvantages:
* Frequent occurrence of blossoms
* Waiting for the first layer to dry can be time-consuming

SUNNY SIDE UP
21" × 29" (53cm × 74cm)
140-lb. (300gsm) cold-press Arches

Glazing to Create Shape and Form
Each of this mum's petals was defined individually, glazed with its own shadow and shape. The collection of glazed petals makes the flower. To begin, apply several light washes to the paper to establish the light color of the flower. These light washes become the highlight of the flower, giving the painting a muted tone that creates a feeling of serenity.

Charging

When you want to create a soft effect with no hard edges, painting wet-into-wet, or charging, is the safest method. This technique differs from glazing in that the paint should not dry between layers.

Using clean water, generously wet the area you want to charge. Not wetting the area sufficiently causes irregular charging—while you work on one corner, another will dry out. The paper should be very wet, but without puddles.

Apply pigment to the top of the area and let the water distribute it over the surface. Completely saturate a brush with water, squeeze out the excess with a dry rag, and use it to smooth out the lighter areas. In a larger area, you can use a dry brush to smooth out any dark spots.

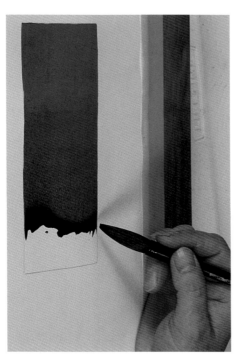

Wet-Into-Wet Application

Generously wet the area you want to charge and apply your first color, making sure the paper does not dry before applying another. When you're finished, you'll see a smooth transition from color to color with no hard edges.

Charging Pros and Cons

Advantages:
* Covers a large area without time pressure
* No hard edges

Disadvantages:
* Dilutes the pigments on the paper, resulting in lighter application (use stronger pigments as needed)
* Not easy to control—if the area is wet, the pigment will cover it

Using Wet-Into-Wet to Make Different Hues

To create PEONY AT DAWN, I rendered each petal with clean water and then applied the pigment. The lighter petals were made with diluted pigment and the darker petals with darker, thicker pigment.

PEONY AT DAWN
15" × 22" (38cm × 56cm) 140-lb. (300gsm) cold-press Winsor & Newton

Light and Value

Basically, value is the relative lightness or darkness of a color. It is directly related to how light shapes a three-dimensional image. More light results in a higher value, while less light produces a lower value. Use this knowledge to create the highlights and details that make a painting leap from the page.

Picture light falling on a ball. Six distinct tones are created:

Core shadow: the darkest dark of the object. This side is directly opposite from where the light is hitting.

Cast shadow: the shadow created by the object. You can best achieve this by using the object's complementary color.

Highlight: the lightest light of the subject. This is where the most direct light hits.

Local color: the actual color of the object, unaffected by lighting or shadows.

Reflected light: light reflected from the ground into the core shadow. This will help separate the ball from the shadow.

Reflected color: colors reflected from the object into the cast shadow. This helps show the relationship between the object and its shadow.

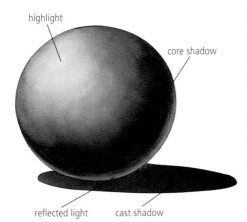

Value in Black and White
Color can be a distraction when considering value placement. With a black and white illustration and solid black cast shadow, you easily can determine the value.

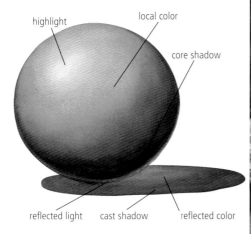

Value in Color
With a yellowish ball, the cast shadow contains some of the object's local color. Use blue-violet, yellow's complement, for the cast shadow to help bring out the subject sharply.

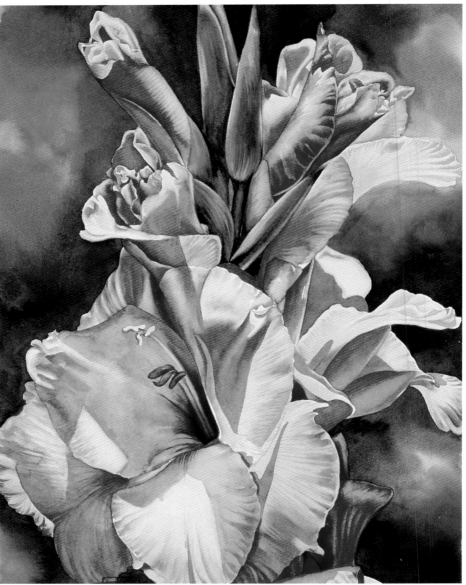

Real-Life Values
Composing values in real-life settings is a little more complicated. Value changes from object to object based on the lighting and spatial relationship. Shadow colors also can be changed dramatically by the surroundings.

Natural Sunlight Effects

Artists who paint flowers often take reference photos outdoors. The magical thing about these photos is the way they can capture varying intensities of light playing upon their subject. Light can take an ordinary flower and make it extraordinary. You should strive to capture that effect with paints.

Strong, direct light creates shadows with high contrast that you can incorporate into any composition to add subtle but dramatic qualities. This will help you create the paintings you envision.

Experimenting With Light

The options for creating mood and expression with lighting are limitless—explore the different directions of light at various times of the day and the effect the light has on your subject. Capture varying levels of contrast between intense shadows, local color and highlights.

I find the ideal time to take reference photos is early on a clear morning. The low-angled light conditions enhance the subject by capturing clear values with sharp, crisp colors. The highly visible contrast with the shadow will help you see the three-dimensional form of the subject clearly. The lighting in late afternoon is just as good, but the blossoms won't be as fresh.

Try setting cut flowers on a window sill when the sun showers the sill with light—from the east in the morning, the south in the early afternoon and the west in the late afternoon. With enough space, you can shoot the same subject with all different kinds of lighting.

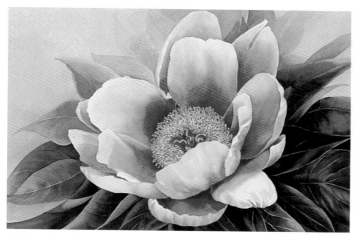

Diffused Light
When the sun is hiding behind a cloud or your subject is stuck in the shade, it's the perfect time to capture images with a soft, gentle, somber mood. There are neither harsh cast shadows nor highlights, just undistorted subjects in their natural surroundings.

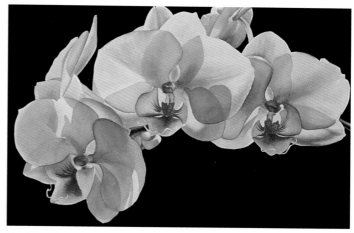

Backlight
Light coming from behind a subject can make the edges glow, giving it a strong, dramatic impact. The background was dropped out of this image, enhancing the effect of the light streaming through the petals. Backlighting tends to make subjects of varying degrees of opacity and translucence glow from within.

Direct Overhead Light
Strong overhead lighting creates dark shadows of great contrast. This produces images with fewer details and gives you little opportunity to play with shadow and mood, but it creates bold and stark subjects.

Sidelight
Light from the side is the most common in general photo shooting. On a sunny day, sidelight from various angles on the right or left creates wonderful shadows on the opposite side. These shadows define the contours of a subject gracefully.

Special Effects

After practicing washing and glazing, explore some of the creative ways to make interesting textures using tools and techniques other than brushes. The use of unorthodox materials is limited only by your imagination. It's up to you whether or not special effects are incorporated into a painting, but try these techniques at least once just to have a little fun.

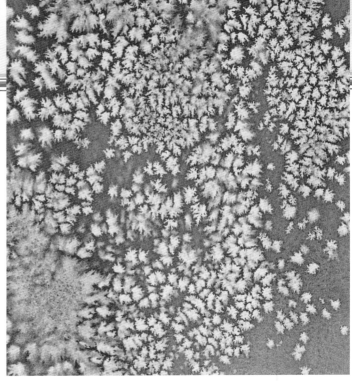

Salt Effect
Sprinkle some table salt onto your paper while it is still wet (but has no puddles). Where the salt lands, little starbursts form. You can control the direction of the starbursts by using a hair drier or fan to distribute the salt. Use this technique to soften a solid, one-color background.

Water-Spray Effect
You can use a spray bottle to maneuver your pigments in a very interesting way. This effect works better on hot-pressed paper, synthetic paper or illustration board. Sprinkle and spatter the pigments on dry paper and spray water where you want them to spread. You can even tilt the board to dictate where the pigment goes. This technique is good for creating leaves and bushes.

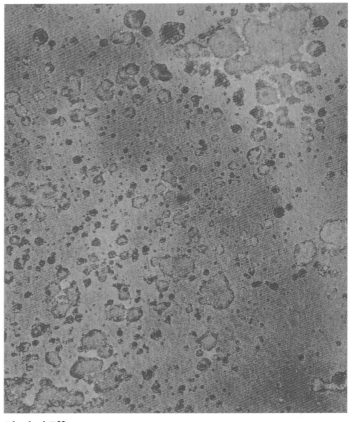

Alcohol Effect
Spraying alcohol over a damp wash results in gentle, soft dots. These textured dots are a little darker than the original color.

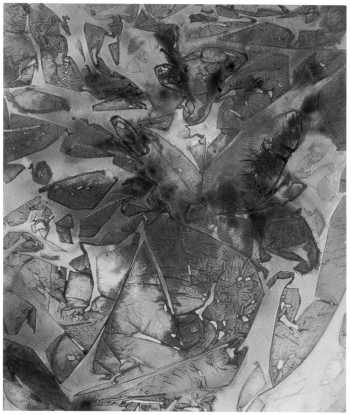

Plastic Wrap Effect

Adding a rough and irregular texture here and there can bring excitement to your painting. Use enough wrinkled plastic wrap to cover the entire painted, wet surface and use a finger tip to press the plastic down on places where you want texture. Let the surface dry completely before taking off the plastic wrap. This produces areas of varying value and makes great rock formations.

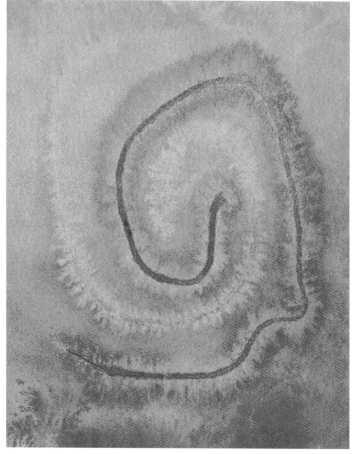

String Effect

Dip a piece of cotton string into your paint and place it on the surface of the paper. The water and pigment surrounding the string seperate and create an interesting texture.

Dry-Brush Effect

Using a brush with little to no water creates a scratchy, grainy texture, an excellent effect for old, dead wood and rock formations. This technique works very well with cold- and rough-pressed paper's bumpier textures. Using any kind of brush, drag the tip for the details and small areas, and use the body for a bolder texture.

 Saving Highlights

Using Masking Fluid

In watercolor, saving white spots for highlights is challenging and time-consuming. Using masking fluid to save white areas is a practical necessity in some situations. Use it here to portray a tangerine with a white rind.

To create the rind texture, spraying or salt techniques will not work properly. Since it would take too long to paint around the white, use masking fluid to easily save the highlights within the texture. This demonstration uses a combination of masking fluid, washing, glazing and drybrushing to finish the details in the tangerine. To achieve the opposite texture, the velvety feel of the zinnia, you use a different method.

Materials

15" x 22" (38cm x 56cm) 140-lb. cold-pressed Arches ❀ Masking tape ❀ Masking fluid ❀ Nos. 8 and 10 rounds ❀ Toothpicks ❀ Rubber cement pickup

Color Palette

Aureolin ❀ Indigo ❀ Permanent Alizarin Crimson ❀ Prussian Blue ❀ Quinacridone Red ❀ Scarlet Lake ❀ Sepia ❀ Winsor Green (blue shade)

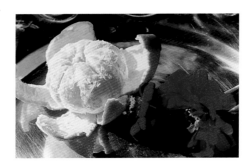

Reference Photo

Masking Fluid Applied

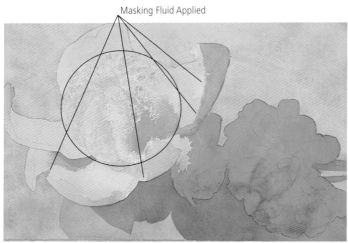

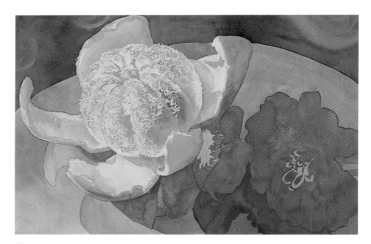

1 Apply the Masking Fluid

Apply masking fluid with a toothpick where you want to save the white of the paper. Let it dry. Apply a thin wash over the tangerine with premixed Aureolin and Quinacridone Red using a no. 10 round. For the zinnia, apply the same mixture with a larger amount of Quinacridone Red. Apply a wash of diluted Prussian Blue for the background and reflection with a no. 10 round.

2 Apply a Second Undercoat and Remove the Masking Fluid

Apply Quinacridone Red and Aureolin wet-into-wet to the tangerine and zinnia. Concentrate on the darker values of the tangerine and apply one more coat of Quinacridone Red to the zinnia and reflection. Glaze Winsor Green (blue shade) around the tangerine and zinnia and Prussian Blue over the background with a no. 10 round. After it dries, remove the masking fluid using rubber cement pickup.

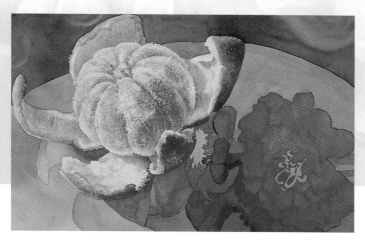

3 Develop the Tangerine

Glaze thinned Prussian Blue onto the shadow on the peel with a no. 10 round. Lay down a wash of Quinacridone Red while this is still wet, and apply Aureolin wet-into-wet. Let the Aureolin bleed through the Quinacridone Red. For the darker areas, carefully drop in Sepia.

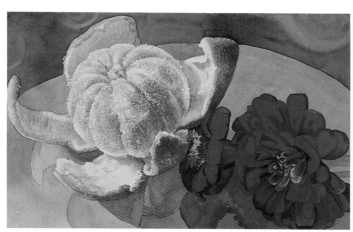

4 Develop the Zinnia

Using nos. 8 and 10 rounds, glaze Scarlet Lake and Quinacridone Red onto the petals. Create the shaded areas by adding Sepia. Using Sepia instead of Prussian Blue makes the red deeper and richer. The pigment should be somewhere between creamy and juicy on the palette. If it's too thick, the brush won't move smoothly on the paper, but too much water will weaken the hue you want.

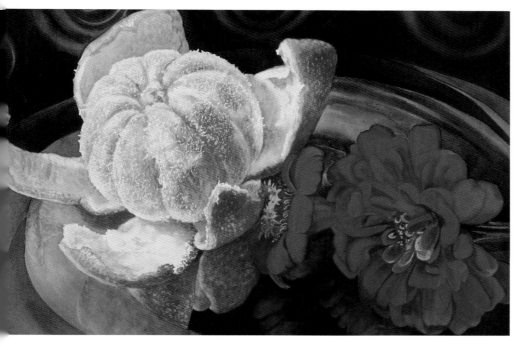

5 Finish the Background

Develop the reflection of the zinnia and tangerine using Scarlet Lake, Quinacridone Red, Sepia and a no. 8 round. Add Prussian Blue for the darkest value.

Keep in mind that blue complements orange. Using bluish tones in the background makes the orange stand out and sparkle. Use Prussian Blue, Permanent Alizarin Crimson, Indigo and a touch of Winsor Green (blue shade) to finish the background.

CLEMENTINE AND ZINNIA
14" × 21" (36cm × 53cm)
140-lb. (300gsm) cold-pressed Arches

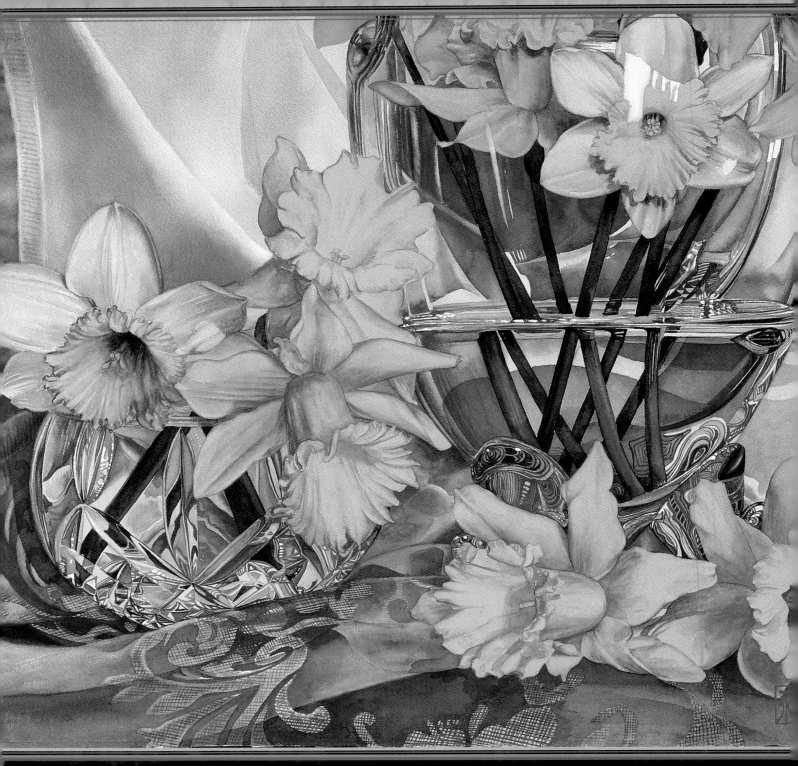

Characteristics of Flowers

The lack of radio, television, computers and video games in my youth helped me enjoy and learn about nature. Growing up, I was surrounded by an abundance of both domesticated and wild flowers. Naturally, the flower fields were my playground and the flowers, my playmates. My sister and I often invented games that involved counting flower petals and leaves—the one who found the stem with the most leaves or the flower with the most petals won.

We made rings, bracelets and tiaras by knotting and braiding clovers. Dandelions became accents on our hairpins, and the pink and reddish color of new sap or crushed flower petals became our nail polish. I learned all about flowers when I was young, so now I paint the flowers that I remember as well as the ones I now see in my garden, at the nursery or in the wild.

Flowers are my first and greatest passion as a painter because I live with them, I love them and I know them. I am comfortable painting flowers, and it makes me happy. I used to call daffodils, tulips, hyacinths, gladiolus and other such flowers "fancy flowers" because my mom didn't have them in her garden. Now I grow all of them in my garden, but of course, I still love the clovers and dandelions I grew up with. I will never grow bored of trying to capture the abundance and beauty of nature until I lay my head down to rest!

DAFFODILS
22" × 30" (56cm × 76cm)
300 lb. (640gsm) cold-press Arches

Learning the Details

Every flower has its own color, form, texture, size and personality. Some like to bloom in the morning, some later in the day, some in the evening. Some like spring, while others favor summer, fall or winter. However, most flowers are made of the same distinctive shapes and details.

Flower Petals

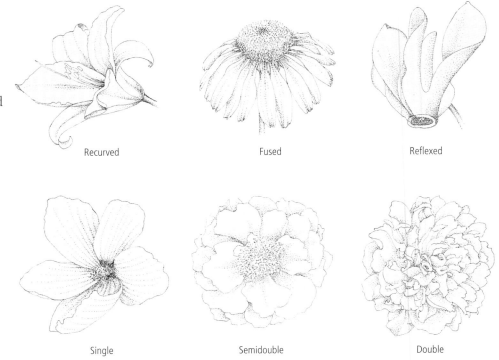

Recurved Fused Reflexed

Single Semidouble Double

Flower Structure

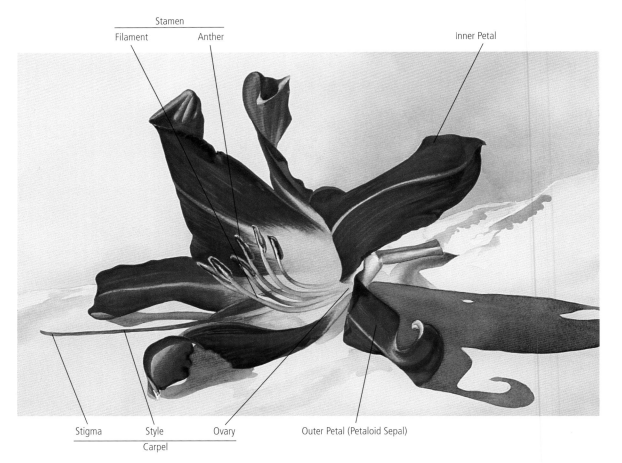

Stamen

Filament Anther Inner Petal

Stigma Style Ovary Outer Petal (Petaloid Sepal)

Carpel

Flower Shapes

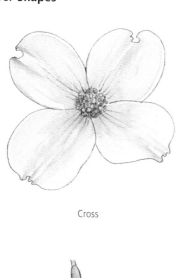

Cross

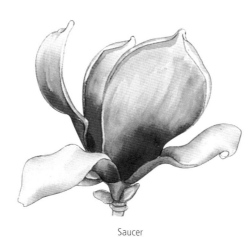

Saucer

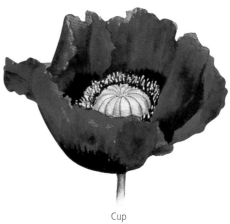

Cup

Trumpet

Rosette

Pom-Pom

Salverform

Funnel

Creating Unusual Petals

The iris's distinctive and unusual petals make a beautiful subject for a painting. Use heavily diluted pigment to create the lighter values of the petals. A touch of thicker color creates the illusion of a ruffled crease.

To follow the steps in this demonstration, you will use nos. 4, 8, 10 and 12 rounds. Change your brush size based on the size of the area you have to cover, using bigger brushes for larger areas and smaller brushes for smaller areas.

Materials

140 lb. (300gsm) cold-press Arches ❀ Mechanical pencil ❀
Nos. 4, 8, 10 and 12 rounds

Color Palette

Aureolin ❀ French Ultramarine ❀ Gamboge ❀ Prussian Blue ❀ Quinacridone Red ❀ Quinacridone Violet

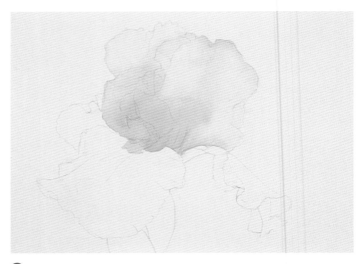

2 Glaze the Standard

Apply a thinned glaze of Quinacridone Red onto the uppermost petal. Next, gently glaze a mixture of Aureolin and Gamboge over the bottom center using a no. 8 round. Yellow pigment doesn't have a tendency to spread out in wet Quinacridone Red, so gently blend the yellow color with a clean, damp brush.

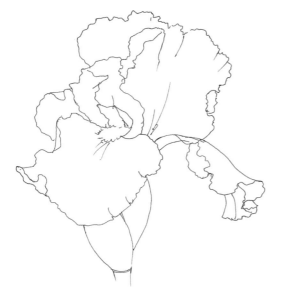

1 Draw the Iris

Accurate contour lines are essential in portraying a realistic iris. Carefully study how the ruffles curve and connect to one another.

Parts of an Iris

Falls: three large petals that spread downward; each petal has a beard and two hafts
Beard: white or colored hairs in the middle of each fall
Haft: the portion of the fall adjacent to the beard
Style arm: three small, petal-like branches arching over the center
Standards: three petals smaller than the falls that stand upward around the center of the flower

3 Glaze the Falls

Glaze the lighter local color of the falls (the downturned three petals that have fuzzy hairs) with Quinacridone Violet and French Ultramarine using a no. 8 round. Adding the glaze on the falls establishes the body and color of the iris. Let the paint dry.

4 Define the Center

With a no. 8 round, glaze the center of the iris with Aureolin, Gamboge and Quinacridone Red for a deep, rich color. Let each layer dry before the next color application.

5 Detail the Standard

Using a no. 4 round to apply color and a no. 10 round to fade and blend, start to develop the details of the creases on the iris' standards and vein using Quinacridone Violet, French Ultramarine and Quinacridone Red. Apply paint with thin, consistently choppy brushstrokes to portray the delicate, fine petals.

6 Detail the Falls

Using nos. 10 and 12 rounds and repeating the same colors—Quinacridone Violet, French Ultramarine and Quinacridone Red—define the falls by glazing with more pigment to create their darker values. Using the same colors, add the veins.

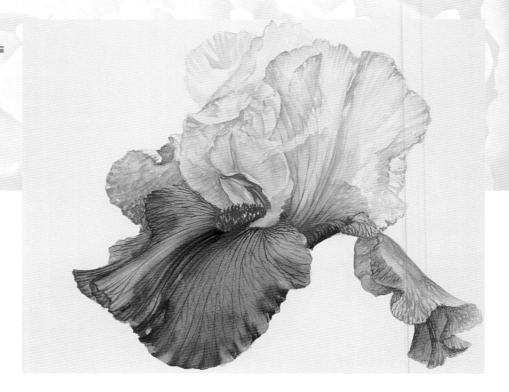

7 Add the Background

To create a harmonious background that illuminates the iris, apply darker values than those in the flower. To show the lushness of spring, the natural setting of irises, apply Prussian Blue and French Ultramarine wet-into-wet with a no. 12 round to produce a clear, open sky with a refreshing look.

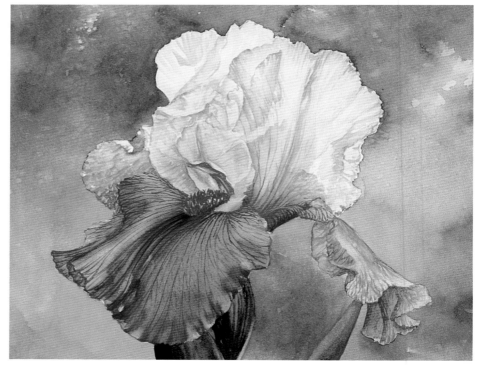

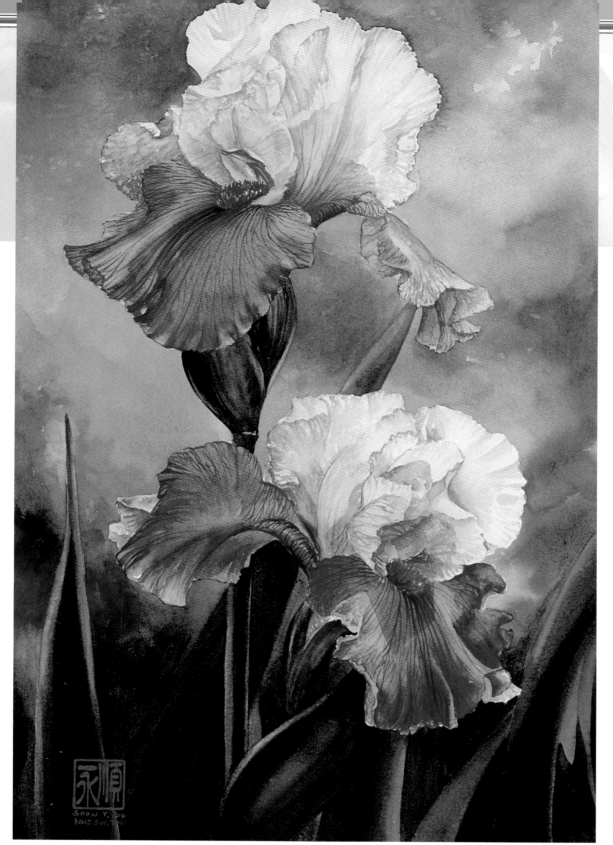

SPRING LADY
14" × 21" (36cm × 53cm) 140-lb. (300gsm) cold-press Arches

8 Finish the Painting

Sparingly apply touches of colors that are already used in the flower for overall harmony within the painting.

Portraying Thick Petals

Painting a large, smooth area is not always as easy as painting smaller spaces. Producing large, smooth areas requires more discipline and control. This demonstration shows how to model the large, thick petals of the lily. For this demonstration, you will need a full sheet of paper, 22" × 30" (56cm × 76cm).

 Materials

2-inch (51mm) and 3-inch (76mm) hakes ❈ 300-lb. (640gsm) cold-press Arches ❈ Mechanical pencil ❈ Nos. 8, 10 and 12 rounds

 Color Palette

Aureolin ❈ Cadmium Yellow Light ❈ Gamboge ❈ Hooker's Green ❈ Permanent Alizarin Crimson ❈ Permanent Rose ❈ Prussian Blue ❈ Sap Green ❈ Sepia ❈ Winsor Green

2 Apply the Second Wash

Apply a thin wash of Permanent Alizarin Crimson. Layering red over yellow creates the peach color of the flower. Use a 3-inch (76mm) hake and spread the color over the background. This layer will unify the elements of the painting.

1 Apply the First Wash

Wet the paper using a 3-inch (76mm) hake. Apply a thin wash of Aureolin and Gamboge on the center of the flower as smoothly as possible. While the surface is still wet, use a dry 2-inch (51mm) hake to soften and blend the area with short, fast strokes. A wet brush will make streaks instead of feathering and blending, so clean and dry your brush often. Apply a wash of Cadmium Yellow Light to the background.

3 Establish the Color

Using a no. 10 round for pigment and a no. 12 round for blending, glaze premixed Cadmium Yellow Light and Gamboge onto the center of the flower and the buds around it. This yellow begins to create the lily's rich, deep color.

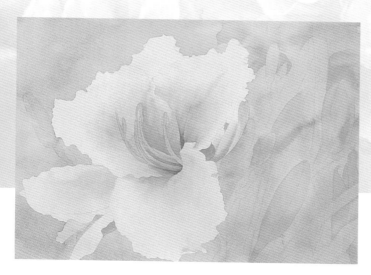

4 Separate the Flower From the Background

Using a no. 8 round for pigment and a no. 12 round for blending, glaze Hooker's Green on the center and outside of the flower. This helps define the flower.

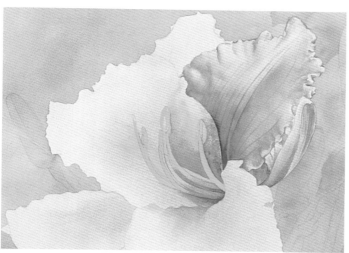

5 Define the Petals

Using one no. 12 round to glaze the Permanent Rose and a clean, dry no. 12 round to blend, define the flower petals. Where the shadow falls, the reddish color should be stronger. Repeat the glazing until the inner and outer layers are done. When defining the ruffle area, constantly blend with a clean brush to prevent hard edges.

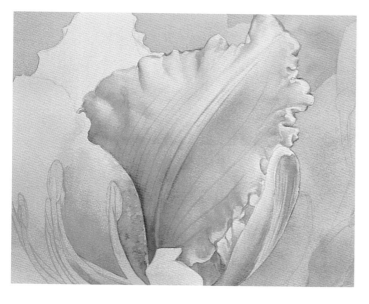

6 Detail the Petals

To portray the thickness of lily petals, glaze the edges very sharply and gently, leaving very few bumps. Alternate between a no. 8 round for detail and a no. 12 round for blending. This touch of glazing will make the edge appear as though it's curled out and rolled back, as opposed to thin petals, which have no curl at the edge. With your no. 8 round, draw the gentle, thin veins.

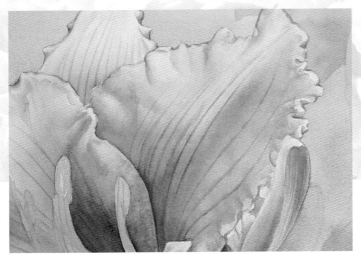

7 Add Veins to the Petals

Mix Permanent Rose with Prussian Blue on your palette and use a dry no. 8 round to draw a thick, rough vein. Create little valleys of a lighter color between the veins to give the petal a wavy appearance. Glaze Hooker's Green in the center and, after it dries, glaze a layer of the complementery Permanent Rose to make a darker value.

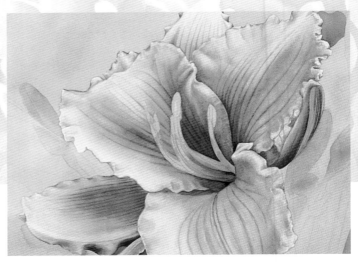

8 Apply a Cooling Wash

Apply a wash of diluted Prussian Blue with a no. 12 round. The blue changes the warm color to a cooler, more settled one. Blue makes the color richer and the red more subtle.

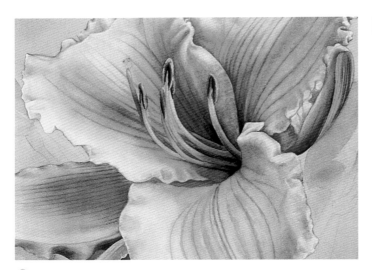

9 Detail the Stigma and Stamen

The dark value at the bottom of the stigma and stamen makes them appear to come out of the flower's center. Without a dark enough value, they appear to float on the petals. Use a no. 8 round to finalize the details, alternating between Hooker's Green and Permanent Rose. For the anther, glaze premixed of Permanent Alizarin Crimson and Sepia.

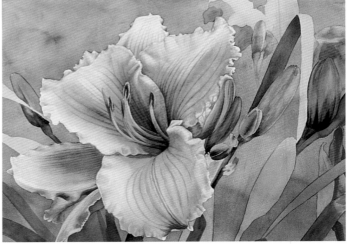

10 Finalize the Lily

Glaze the ruffle with premixed Prussian Blue and Permanent Rose to define it. Deepen the shadow and vein with the same mixture and a no. 8 round. Using nos. 12 and 8 rounds for the different-sized background areas, apply Aureolin wet-into-wet in the lighter area. Use Prussian Blue and Permanent Rose for the rest of the background. Glaze the leaves with Hooker's Green using a no. 10 round.

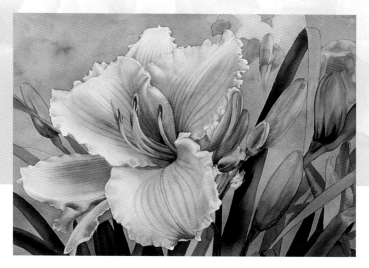

11 Complete the Background

Develop the leaves, bud and withered flower in the background with your no. 10 round. For the leaves, glaze premixed Hooker's Green, Sap Green and Sepia. Glaze the buds and withered flower with Hooker's Green and Sap Green. The withered flower needs more Permanent Rose.

Apply premixed Indigo and Permanent Alizarin Crimson wet-into-wet to the background with a no. 10 round. This harmonizes the leaves and the background, ridding the painting of unnecessary contrast. After the background is done, darken the leaves with premixed Winsor Green and Permanent Alizarin Crimson. This complementary color mixture produces a brilliant, dark green.

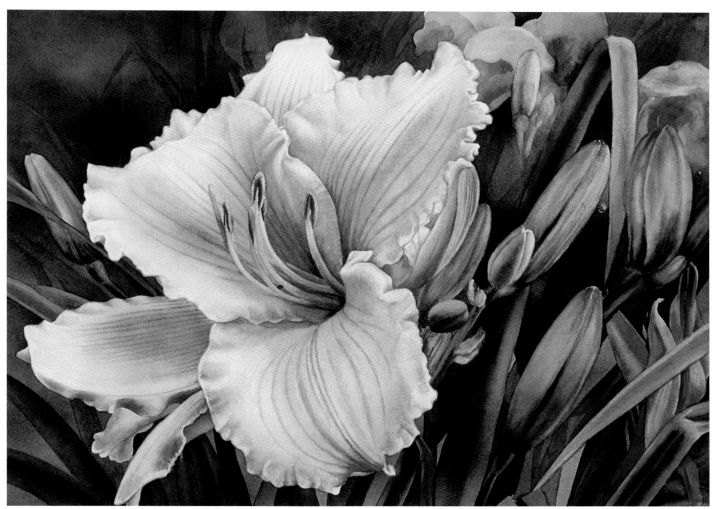

12 Finish the Painting

Finally, after all the elements are done and you like the depth and feelings invoked by the painting, you can add the final touches: clean out the edge of the flower, soften any undesirable hard edges, and add any missing details. To soften the edges of the flower and leaves, use a scrub brush to lift off some pigment. Don't try to clean out the color completely, just soften the edge.

SALMON LILY
22" × 30" (56cm × 76cm) 300-lb. (640gsm) cold-press Arches

DETAIL DEMONSTRATION

Creating Buds and Stems

Buds make a beautiful subject as well being useful as elements that liven up a background. This hibiscus bud demonstrates the understated loveliness that buds and stems can create on their own, apart from a blossom.

Materials

140-lb. (300gsm) cold-press Arches ❋ Mechanical pencil ❋ Nos. 8, 10 and 12 rounds ❋ Plywood board ❋ Masking Fluid

Color Palette

Aureolin ❋ Gamboge ❋ Hooker's Green ❋ Indigo ❋ Permanent Alizarin Crimson ❋ Quinacridone Magenta ❋ Quinacridone Red ❋ Sepia ❋ Winsor Green

1 Apply the Undercoat

Apply Aureolin and Hooker's Green wet-into-wet on the stalk and pointed calyx using a no. 12 round. Use the tip of the brush for the calyx. Be sure to create differing values, from lighter yellow to darker green. Apply masking fluid to the highlight on the bud and let it dry. Then apply thinned, pre-mixed Quinacridone Red and Quinacridone Magenta on the flower bud with a no. 10 round.

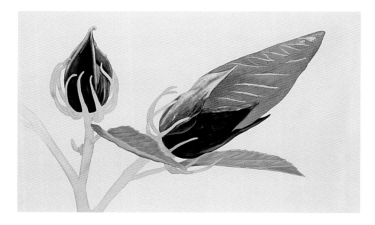

2 Paint the Inner Calyx

Use various combinations of Hooker's Green and/or Winsor Green with a touch of Quinacridone Red and/or Permanent Alizarin Crimson to create the various darker shades of green you need for the inner calyx. Apply these colors with a no. 10 round. In the shadow, add Winsor Green and a touch of Sepia for the darkest area. On the leaves, apply a diluted mixture of either green mixed with Aureolin. After it dries, glaze diluted, premixed Quinacridone Red and Quinacridone Magenta over the leaves.

3 Develop the Outer Calyx

Using the same palette from the previous steps, paint the outer calyx. Alternating between nos. 10 and 12 rounds, gently model the string-shaped calyx. Apply diluted Aureolin wet-into-wet on the lighter side, then apply Permanent Alizarin Crimson to the bottom of the stalk and Winsor Green under the buds. Notice the stem is not flat. Remove the masking fluid from the flower bud using your fingertip.

4 Define the Details

To warm the cool red, glaze Gamboge over the flower bud with a no. 10 round. Let it dry, then, using the same brush, glaze premixed Quinacridone Red and Quinacridone Magenta over the bud. Be careful to preserve the highlight. Define and darken the stem and stalk by separately glazing the complementary Quinacridone Red and Hooker's Green over them, as well as the shadow on the right side of the leaf stalk.

5 Finish the Painting

To model the shape of the flower bud, premix Sepia, Quinacridone Magenta and Indigo on the palette and glaze it on the edge of the bud with a no. 10 round. Use a clean no. 10 round to blend. You can use various combinations of these three colors to produce different shades and depths.

HIBISCUS BUDS
15" × 22" (38cm × 56cm)
140-lb. (300gsm) cold-press Arches

What is "Leaf Green"?

Almost all the flowers you will be painting have leaves. Take time to notice their interesting colors. You'll learn never to use any kind of green directly out of the tube. Without mixing, green pigment seems too neon or raw compared to the green shades found in nature.

To see this, paint a sample of pure green pigment and compare it to the trees and plants outside. You will discover that the green shades of nature blend in any number of colors, including red, brown, blue and yellow. The season you wish to portray also affects the shade of green. In spring, it may be a little yellowish; in summer, a dark and deep green; in fall, red and orange come into play; and in the winter, you see blue tones.

Play with the greens on your palette to find what mixture you like the best. Here are samples of some greens mixed with one other color. You can use these colors to bring green down to earth.

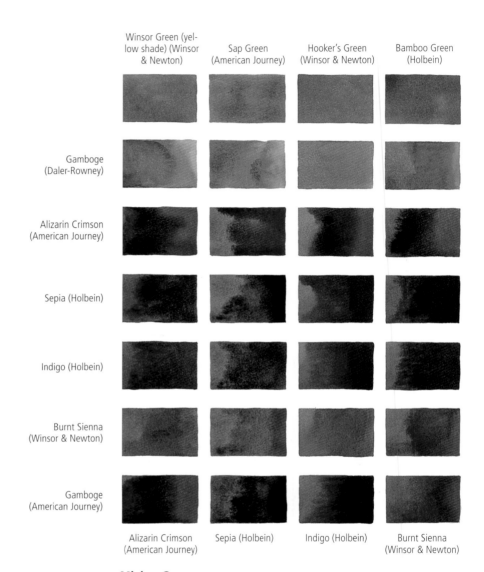

Mixing Greens

The greens appear as pure pigment across the first horizontal row. Each of them is then mixed with different hues (listed down the left side).

The bottom row differs in that it has a Gamboge undercoat. The colors mixed with these yellow-green combos are listed along the bottom. The undercoat of yellow creates a deeper and richer color.

Grape Leaves

The grape leaf has a bumpy texture and reddish vein. An older grape leaf usually has a darker green value, and a new, young leaf has a lighter color.

 ## Materials List

140-lb. (300gsm) cold-press Arches ※ Mechanical pencil ※ Nos. 8 and 10 rounds

 ## Color Palette

Aureolin ※ Gamboge ※ Hooker's Green ※ Permanent Rose ※ Sepia

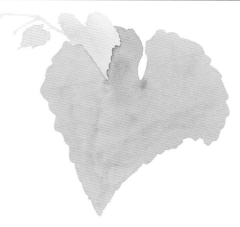

1 Apply the Undercoat

Draw the leaves, including the center vein, which indicates the direction and shape of the leaves. Then apply Aureolin on all three leaves with a no. 10 round and, after it dries, glaze Hooker's Green on the largest leaf and diluted Hooker's Green onto the middle one. Glaze only Gamboge, no green, on the smallest leaf.

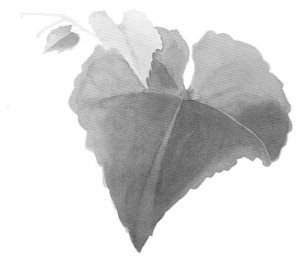

2 Glaze With the Local Color

Start to glaze each section of the largest and middle leaves separately with Hooker's Green using a no. 10 round. Glaze Permanent Rose on the veins of all three leaves. Without the texture you'll add in the next step, the leaves will have a slick, smooth surface.

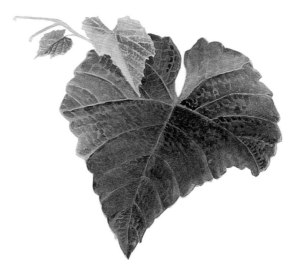

3 Add the Details

Using your no. 10 round, start to develop details and bumps on the leaves. Drybrush premixed Hooker's Green and Permanent Rose, later adding Sepia for the darkest green of the bumps. Glaze the bumps around the vein individually to save the lighter color. Glaze the smallest leaf with Permanent Rose and Sepia to create its darker value.

Rose Leaves

Roses have several small leaves on one stem, and the leaves have teeth. Usually, old leaves are green with reddish veins, and young, new leaves have a deep burgundy hue. Here is how to paint an old leaf.

Materials List

140-lb. (300gsm) cold-press Arches ❋ Mechanical pencil ❋ Nos. 6, 8 and 10 rounds

Color Palette

Bamboo Green ❋ Burnt Sienna ❋ Quinacridone Red ❋ Sap Green

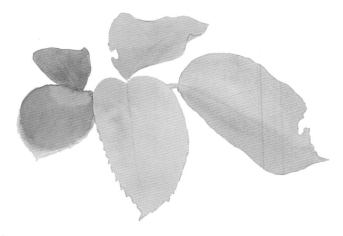

1 Apply the Undercoat

Draw the leaf, then apply a light wash of premixed Sap Green and Burnt Sienna with your no. 10 round.

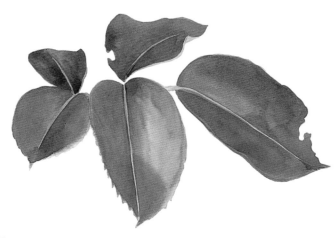

2 Glaze With the Local Color

Glaze the leaf with premixed Bamboo Green and Sap Green using your no. 10 round, and add the line for the vein with Quinacridone Red and a no. 8 round.

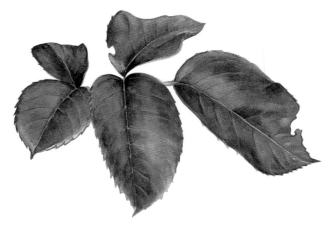

3 Add the Details

Using your no. 6 round, draw the thin lines of the veins on the leaf and glaze darker green between them. Draw and define some teeth on the leaf with the same brush.

Autumn Pear Leaves

Pear leaves are shiny and waxy green. When their color changes in the fall, the shining green turns into a yellowish orange color. Some develop black dots along both sides of the center vein.

❈ Materials List

140-lb. (300gsm) cold-press Arches ❈ Mechanical pencil ❈ Masking fluid ❈ No. 8 round ❈ Toothpick

❈ Color Palette

Aureolin ❈ Gamboge ❈ Quinacridone Red ❈ Sepia

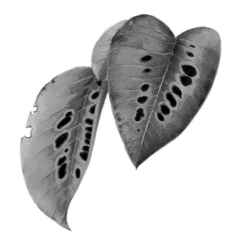

1 Apply the Undercoat

Apply masking fluid in the center of the vein with a toothpick. This will preserve its lighter color. Alternating Aureolin, Gamboge and Quinacridone Red, apply wet-into-wet, yellow-into-red or vice versa with a no. 8 round.

2 Glaze With the Local Color

With your no. 8 round, glaze thinned Sepia over the leaves to tone down the overly brilliant yellowish orange hue.

3 Add the Details

Remove the masking fluid. Using pre-mixed Quinacridone Red and Sepia, glaze the leaf with a no. 8 round. Avoid the vein. Last, paint the black dots using Sepia with a touch of Quinacridone Red using the same brush.

Philodendron Leaves

Philodendron leaves are a dark blue-green and have a waxy appearance. They are huge leaves with large holes in them.

✻ Materials List

140-lb. (300gsm) cold-press Arches ✻ Mechanical pencil ✻
Masking fluid ✻ Nos. 10 and 12 rounds ✻ Toothpick

✻ Color Palette

Aureolin ✻ Bamboo Green ✻ Winsor Green (blue shade)

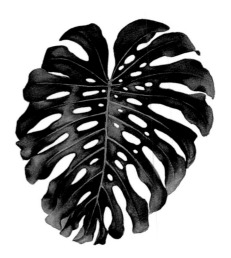

1 Apply the Undercoat

Apply masking fluid to the holes within the leaf with a toothpick; this will lay the groundwork for a faster and cleaner application of color. When it's dry, apply diluted Bamboo Green wet-into-wet with a no. 12 round to cover the whole leaf.

2 Draw the Veins

Draw the wide center vein using a no. 12 round fully loaded with Aureolin, and draw the thin, side vein with a no. 10 round. Apply enough pigment to the veins so they will stay wet. Quickly change from Aureolin to premixed Bamboo Green and Winsor Green (blue shade) applied wet-into-wet. Apply the green mixture from top to bottom. Try to avoid applying green where the yellow lines are, but even if you do, the veins are going to be lighter than the rest of the leaf. Let the colors mingle and flow into each other. Allow the paper to dry.

3 Add the Details

Remove the masking fluid, then glaze the leaf with premixed Winsor Green (blue shade) and Bamboo Green using a no. 10 round for a dark, bluish green.

African Violet Leaves

African Violet leaves are fuzzy and thick with big bumps.

❀ Materials List

140-lb. (300gsm) cold-press Arches ❀ Mechanical pencil
❀ Nos. 8, 10 and 12 rounds

❀ Color Palette

Aureolin ❀ Bamboo Green ❀ Hooker's Green ❀
Quinacridone Violet ❀ Sepia

1 Apply the Undercoat

Draw the leaves and apply a wash of Aureolin with a no. 10 round.

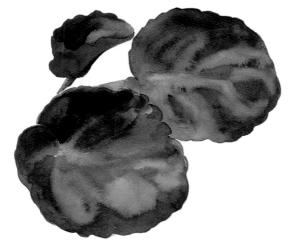

2 Define the Local Color

Glaze Quinacridone Violet onto the edge and back of each leaf using a no. 10 round. Then apply Hooker's Green, followed by premixed Bamboo Green and Sepia wet-into-wet. If excess color remains on the leaves, just remove it with a damp brush.

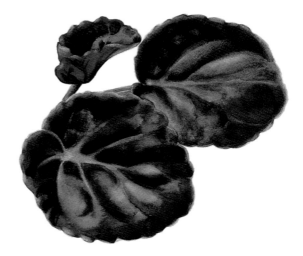

3 Add the Details

Glaze around the thick, fuzzy vein with premixed Bamboo Green and Sepia using a no. 8 round. To create the wavy texture and teeth, make big bumps with a glaze of a dark mixture of Bamboo Green and Sepia. Using the tip of a damp no. 12 round, lift off some of the color from the veins for details.

Dewdrops on Petals and Leaves

 Materials List

140-lb. (300gsm) cold-press Arches ✻ Mechanical pencil ✻ Masking fluid ✻ Nos. 10 and 12 rounds ✻ Toothpick

 Color Palette

Burnt Sienna ✻ Gamboge ✻ Permanent Alizarin Crimson ✻ Prussian Blue

After it rains or early in the morning, the sun shines on the drops of water that sit on or dangle from the leaves and petals of your garden flowers. The sparkly dew is so refreshing, sharp and clean, yet seems nearly impossible to capture on paper.

However, rendering dew can be very simple and fun. Once you master the technique, morning dew in your garden will open your eyes better than a cup of fresh coffee. It's amazing how simple drops of water can transform ordinary surroundings into a beautiful, sparkly wonderland.

1 Draw the Droplets

Paint two separate undercoats; one a wash of Permanent Alizarin Crimson, the other a wash of Prussian Blue and Gamboge. Draw a circle or oval on each. Apply masking fluid with a toothpick to save the highlight, and after it dries, remove some of the paint from the bottom part of the water droplet to differentiate that area from the background.

2 Make Shadows and Highlights

Glaze darker tones of color onto the dewdrops with a no. 12 round, and apply the same dark color to create the cast shadow. In addition to anchoring the dew to the background, the shadow indicates the direction of the sunlight. The color of the dew should always correspond with surrounding colors. Remove the masking fluid.

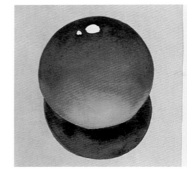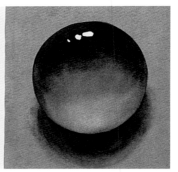

3 Use Shadows to Indicate Light

The shadow of the red dewdrop has a hard edge, indicating strong sunlight. The shadow of the green dewdrop is soft and feathered, indicating soft, diffused light. These effects will be less obvious when you incorporate dewdrops into a painting. With this demonstration, you can see the spectrum for rendering drops of water.

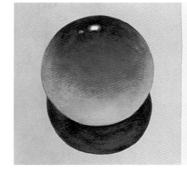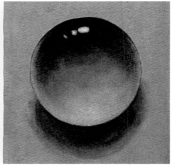

4 Draw a Dewy Petal

Draw an isolated petal with dew. Apply masking fluid to save the highlights. Wash Gamboge over the petal with a no. 10 round, and after it dries, apply Prussian Blue to the background.

5 Glaze the Petal

Glaze Burnt Sienna and Permanent Alizarin Crimson onto the petal with a no. 10 round. Develop the petal as if the dewdrops were not there. After it dries, remove the masking fluid—your highlights will stand out with a hard edge.

6 Soften the Highlight

Soften the edge of the white highlight with a small scrub brush. After scrubbing the pigment from the paper, dab with a soft facial tissue.

7 Define the Color Reflections

The surrounding color defines the color of each dewdrop. Dew on a blue background will be blue, and dew on a red background will be red.

Shadows

When a shadow falls on a flower, it becomes part of the overall flower pattern and creates interesting forms. Use dark cast shadows to create movement and drama. This demonstration shows how to see and paint shadows within a flower instead of separating the shadows from the subject. Use nos. 10 and 12 rounds unless otherwise noted.

Materials List

140-lb. (300gsm) cold-press Arches ❋ 3-inch (76mm) hakes ❋ Mechanical pencil ❋ Masking fluid ❋ Nos. 10 and 12 rounds

Color Palette

Aureolin ❋ Gamboge ❋ Quinacridone Burnt Orange ❋ Quinacridone Gold ❋ Prussian Blue ❋ Sepia

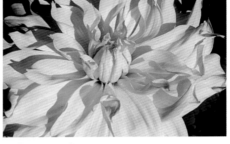

Reference photo

1 Draw the Dahlia

Draw the outline of each petal and the lines of the shadows. Where the shadow gradually turns to form a curved shape, don't draw the indication line. The pencil may be too dark for gradual glazing.

2 Apply the First Wash

Mix enough Aureolin and Gamboge on a palette to cover a half sheet (22" × 15" [56cm × 38cm]). Wet the paper with a 3-inch (76mm) hake and apply the wash with the same brush. This process sets up the highlights of the flower, which will be light yellow instead of white.

3 Glaze the Petals

Because the highlight of the flower is distributed evenly, glaze the darker value of each petal separately with Gamboge using a no. 10 round. This process starts to develop the local yellow color of the dahlia. You will need to develop each petal separately to save the highlights. Where the cast shadow falls, apply undiluted Gamboge and do not blend.

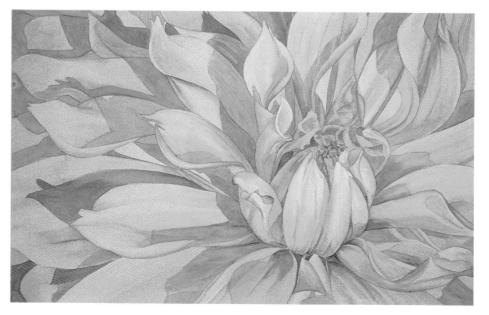

4 Define the Details

Using a no. 10 round for pigment and a no. 12 round for blending, glaze each petal with premixed Quinacridone Burnt Orange, Gamboge and Quinacridone Gold. For the darkest parts of the shadowed areas, apply the same premixed pigment but do not blend. As you work on this portion, step back and view the painting as a whole. You will see the dahlia start to burst out from the paper.

5 Cool Down the Dahlia

Using a 3-inch (76mm) hake, wash diluted Prussian Blue over the entire surface of the painting. The blue makes the painting a little cooler, muting and deepening the overall effect .

Why apply blue at this point? After completing the previous step, the painting looks too warm and red. Blue is the solution, and you will save a lot of time by applying a thin coat over the entire surface rather than painting each individual petal.

6 Add Contrast

You can see the layering of petals within the flower, but the painting needs more contrast to bring out its sparkle. Add Sepia to the palette, and apply premixed Sepia and Quinacridone Burnt Orange on the darkest shadow areas.

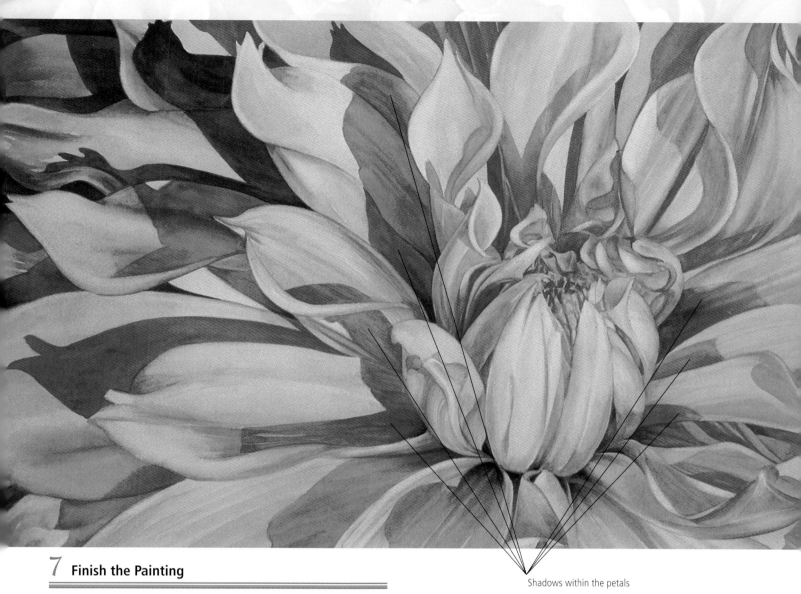

Shadows within the petals

7 Finish the Painting

Continue developing the shadows in the petals. If you find something more to add, do so until you are satisfied. The shadows should develop inside the petals, not separate from them.

YELLOW DAHLIA
15" × 22" (38cm × 56cm)
140-lb. (300gsm) cold-press Arches

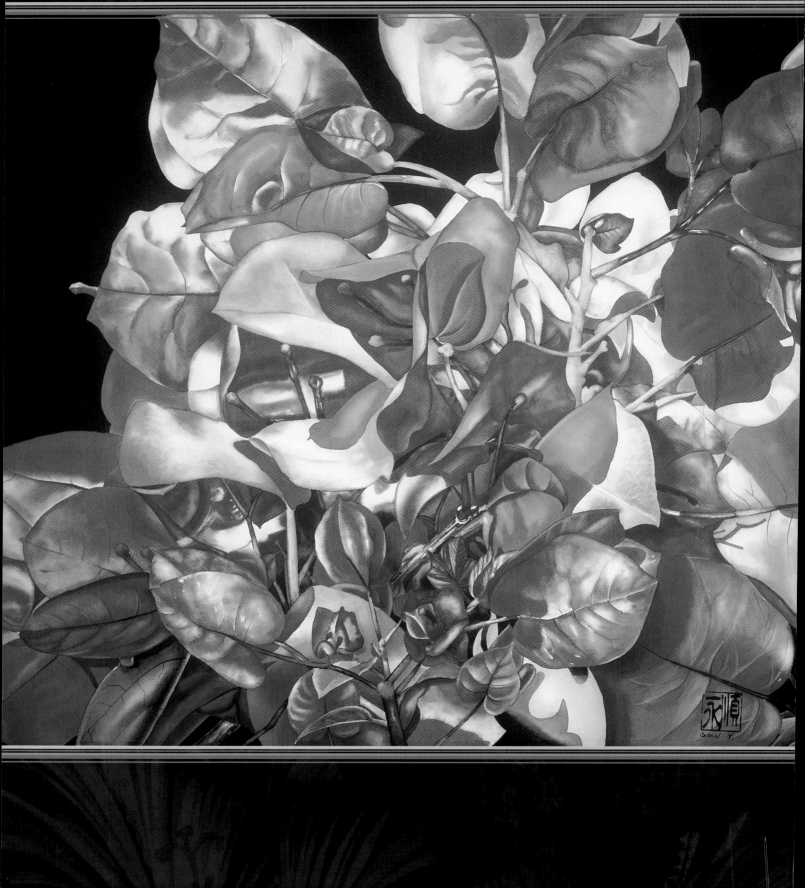

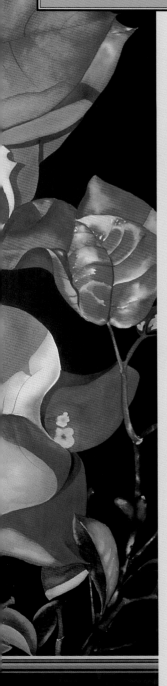

CHAPTER FIVE

Creating Flowers

Just as many small details combine to make a dynamic, realistic flower, an assortment of simple techniques can be combined to create a beautiful painting. In this chapter, all the elements—color, composition, techniques and details—come together. As you follow the steps, you'll find that your painting isn't exactly like the demonstration. That's fine. Remember the importance of experimentation to find you own unique style.

Try to add something more than flowers to your painting. Exaggerate the colors, shapes or sizes, or accentuate realism to avoid the ordinary. Take the extra step toward originality and stronger paintings.

There are infinite choices within any painting, and no unbreakable rules. Don't fear making mistakes or taking new directions—you may wind up with an unexpected gift. Have the courage to make intentional "mistakes" to avoid the same old routine.

BOUGAINVILLEA
22" × 30" (56cm × 76cm)
300-lb. (640gsm) cold-press Fabriano Uno

Create Warmth With Yellow

Using yellow for your first layer helps the later transparent layers glow. Not only does it prevent the later colors from appearing flat, it also gives the subject a rich, warm color. Unless the subject matter is very light, applying too much yellow makes no difference. Since it has a light value, yellow is easily covered up.

Yellow is particularly effective for lending realistic light to your paintings, though you might consider using the white of the paper or other light colors to create highlights in certain situations. For example, you want to start with something other than yellow to portray bluish, purplish or very light pinkish flowers. If a painting is light, a yellow undercoat alters the whole color scheme, changing bluish to green, pinkish to orange and purplish to a muddy color.

However, to portray the strong, deep, rich colors of reddish flowers, an undercoat of yellow is the answer. You want the flowers in your painting to inspire the same reaction in viewers as the real things did when they first grabbed your attention as subject matter. The light and warmth of striking flowers calls for a yellow undercoat.

This demonstration uses a yellow undercoat on some of the flowers and not on the rest so you can see the difference. It's not too dramatic a change, but can subtly and quietly make quite a difference.

 ## Materials List

17" × 30" (43cm × 76cm) 140-lb (300gsm) cold-press Arches ❋ Bristle brush ❋ Masking fluid ❋ Mechanical pencil ❋ Nos. 6, 8, 10 and 12 rounds ❋ Toothpick

 ## Color Palette

Aureolin (Winsor & Newton) ❋ Gamboge (American Journey) ❋ Permanent Alizarin Crimson (Winsor & Newton) ❋ Prussian Blue (Daler-Rowney) ❋ Sap Green (American Journey) ❋ Scarlet Lake (Winsor & Newton) ❋ Sepia (Holbein)

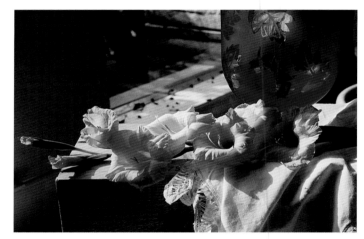

Reference Photo

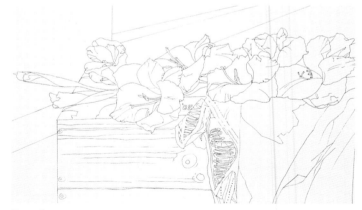

Drawing
Outline the flowers, tablecloth and box. Draw the lines to break up the background.

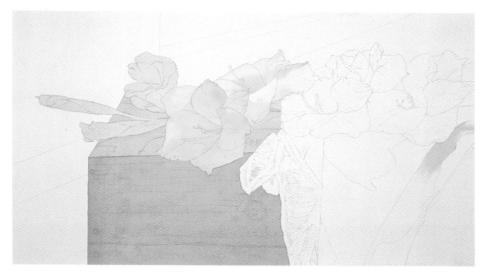

1 Apply the Yellow Undercoat

Glaze Aureolin onto the left side of the composition using a no. 10 round. The flowers on the right side of the composition will not have a yellow undercoat. Use a diluted mixture of Aureolin and Gamboge for the top of the box and a thicker, darker mixture on the front of the box, where it is in shadow.

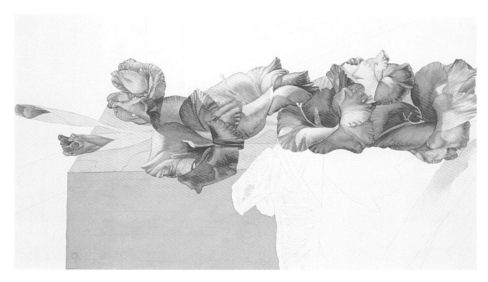

2 Glaze the Flowers

Glaze all the flowers with Scarlet Lake using your no. 10 round, then glaze them a second time using Permanent Alizarin Crimson. Permanent Alizarin Crimson has a deeper value than Scarlet Lake and is useful for defining the flowers' distinctive shapes. Notice the difference between the areas with and without the yellow undercoat. With a yellow undercoat, the flower seems warmer and translucent. Use a toothpick to apply masking fluid to the stamen and stigma to save the lightest parts.

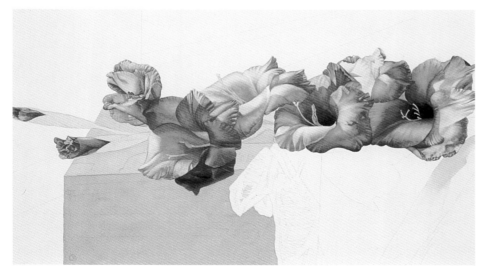

3 Add the Details

To add detail to the flowers, first scrub the places that are too dark with your bristle brush. Then, where they need to brighten up, glaze with Scarlet Lake using a no. 10 round. Use a mixture of Permanent Alizarin Crimson and Sepia for the darker details. For the dark center of the flowers on the right side, use pre-mixed Sepia, Prussian Blue and Permanent Alizarin Crimson to create the darkest hue.

4 Underpaint the Surroundings

Now move onto the surroundings. Glaze a mixture of Permanent Alizarin Crimson and Scarlet Lake right under the flowers for the shadows tinted by the shade of the blossoms. Dilute the mixture and apply it to the tablecloth with a no. 12 round. After that, feather out the pigment with clean water.

Apply a mixture of leftover pigments from painting the flowers—Permanent Alizarin Crimson, Scarlet Lake and some Sepia—to create the dark front of the wooden box.

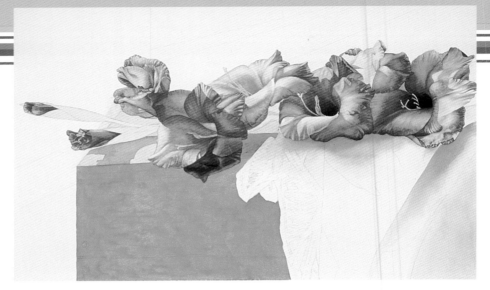

5 Work on the Tablecloth

Mix Prussian Blue with Scarlet Lake on your palette to create a gray hue. With a no. 12 round, glaze this gray over the shadowed areas. Continue until the cloth is covered. Apply the thinned gray on the wooden box to cool down its color.

The first application on the cloth causes it to lose some of the sharp creases and light. Define it with a no. 8 round. Start with thinned colors and, after it dries, develop more layers with the gray color until you achieve the desired values.

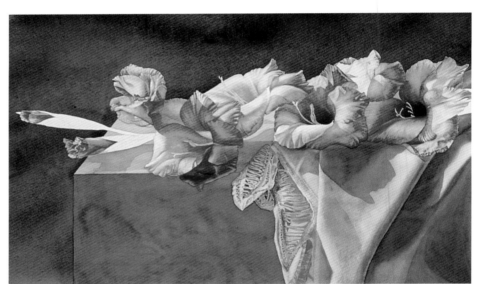

6 Create the Wood Grain

Mix Sepia and Permanent Alizarin Crimson for the primary grain texture. For the darker tones, add Prussian Blue. With a no. 10 round, use a drybrush technique to create the wood grain. Drag your pigment along the direction of grain. Fill the tablecloth holes with a mixture of dark wood grain color. To finish the upper colored shadow from the light filtered through the petals, apply Scarlet Lake and Sepia.

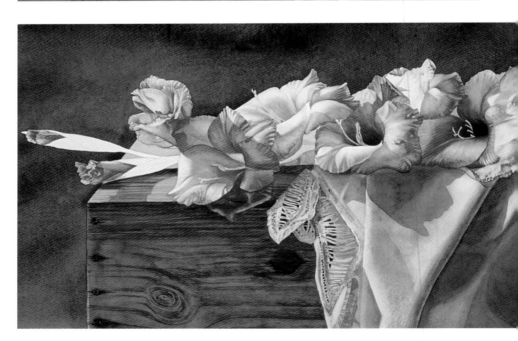

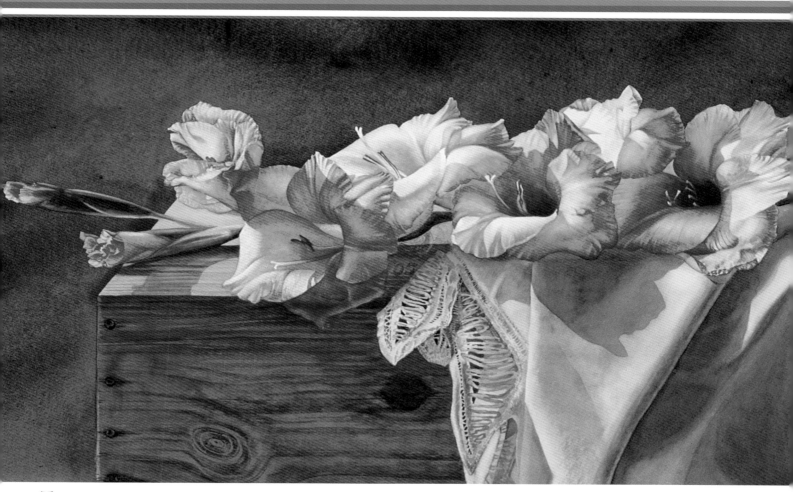

7 Finalize the Painting

Get ready to use a scrub brush to soften and clean the edges. First, use your fingertips to remove the masking fluid from the flower parts, and use a no. 6 round to create the delicate details. Apply Sap Green for the lighter areas of the stigma and stamen, adding Permanent Alizarin Crimson and Sepia for the darker parts. Notice how the yellow undercoat lends the flowers on the left a vibrant, rich, translucent and warm feeling. The flowers on the right look sharp and clean, but lack the warmth.

GLADIOLUS
15" × 30" (38cm × 76cm)
140 lb. (300gsm) cold-press Arches

Add Dramatic Backgrounds

When I was growing up in South Korea in the 1970s, my family didn't have a heating system as wonderful as the ones available now and the winter was brutally cold with sharp north winds. I didn't like cold weather then, and I don't like it now. So imagine how happy I am to see this flower in the early spring!

The saucer magnolia is one of the first to appear each spring. It has thicker, larger blossoms than most flowers, and the blossoms appear before the leaves do, which is a unique and beautiful sight. Saucer magnolias leave an elegant and refined impression with subtle lines, which always reminds me of my sister Toh Toh. She has an oval-shaped face, like the partially opened magnolia, with big eyes, a cute nose and beautiful full lips. Like a tree full of blossoms, she makes me feel full of energy because of her beauty and cheerfulness.

The purple saucer magnolia blossom is special to me because it is rarer than the white magnolia blossom that is prevalent where I grew up. I want to plant lots of trees around the house, but in Texas the summers are too hot for the flowers. It's not easy to grow trees and flowers in the Southwest, but I still try and have several small trees in a shaded area.

Compliment the subtle grace and elegance of the saucer magnolia with a background that's not too busy, but is detailed enough to enchance the delicate nature of these blossoms.

 Materials List

15" × 30" (38cm × 76cm) 140-lb (300gsm) cold-press Arches ※ Mechanical pencil ※ Nos. 8 and 10 rounds

 Color Palette

Aureolin (Winsor & Newton) ※ Burnt Sienna (Winsor & Newton) ※ Gamboge (American Journey) ※ Indigo (Holbein) ※ Prussian Blue (Daler-Rowney) ※ Quinacridone Magenta (Winsor & Newton) ※ Quinacridone Violet (Daniel Smith) ※ Sap Green (American Journey) ※ Sepia (Holbein) ※ Winsor Green (yellow shade) (Winsor & Newton)

Reference Photo

Drawing
Outline the blossoms and branches, and indicate the direction of the background patterns.

1 Build Up the Background

Apply a diluted mixture of Aureolin and Winsor Green (yellow shade) on the background with a no. 10 round. This lime green will establish the lightest value in the background.

2 Create Background Patterns

Using your no. 10 round, drybrush Sap Green over the background to create patterns in a generally horizontal direction, creating the look of grass.

3 Warm Up the Background

Glaze Burnt Sienna sparingly on the background with a no. 10 round to create the warm look of dirt.

4 Add Depth to the Background

Deepen and darken the background by glazing Indigo over it with your no. 10 round. Use thick pigment on the areas you want to be dark, and diluted pigment on the lighter parts.

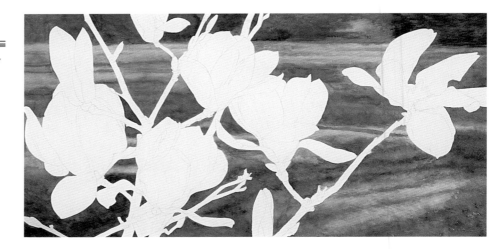

5 Begin the Flowers

Glaze Quinacridone Magenta over the outside of the flower petals with a no. 10 round. Notice that the inside of the flower is almost white except where color reflects from the backside of the petals.

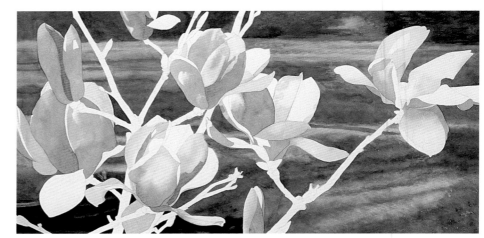

6 Warm Up the Flowers

With your no. 10 round, glaze thinned Gamboge on the bottom of the flower petals and anywhere you want to warm them up. This subtle, light yellow doesn't stand out, but helps the flower connect to the stem by blending the deeper value of the stem with the petals.

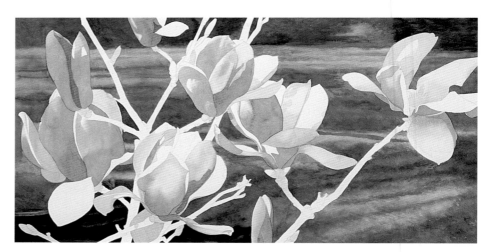

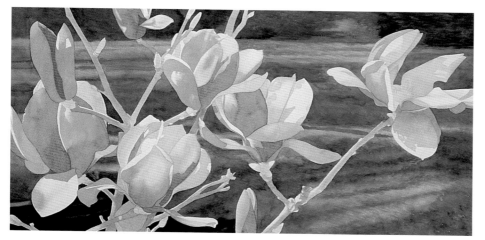

7 Create the Shadow on the Petals

Glaze a mixture of Prussian Blue and Quinacridone Magenta onto the inside shadows of the petals with a no. 10 round. Be very gentle when applying the blue—these are very subtle shades. With a no. 8 round, lightly glaze Indigo onto the branches.

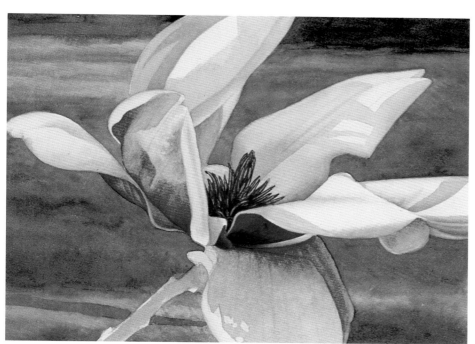

8 Add Detail to the Flowers

Alternating nos. 8 and 10 rounds, glaze premixed Quinacridone Magenta and Prussian Blue on the outer part of the petals to intensify their purplish color. Apply a mixture with more Prussian Blue to the reflected color on the inside of the petals. After it dries, mix Indigo, Sepia and Quinacridone Violet for the darker color of the stamen, the center part of the flower and the outer layer of petals. Use thicker pigment to saturate the paper with this dark mixture using a no. 8 round.

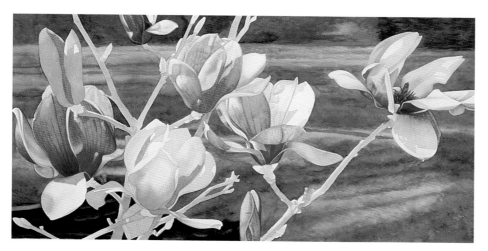

9 Create Warmth

Continue developing the flowers with the same color palette and brushes. To keep your edges intact, avoid applying paint next to wet petals. Glaze Gamboge where needed for warmer tones, such as where the flowers connect to the stems.

10 Finish the Flowers

Complete the flowers by adding veins to the petals using a dry-brush technique and just a little pigment. Draw the vein first with a no. 8 round, then blend and feather the edges before it dries.

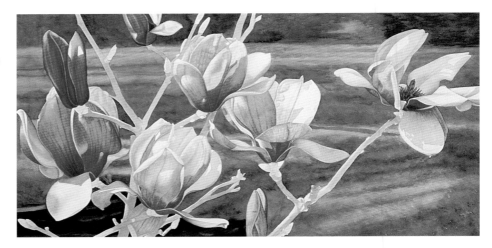

11 Detail the Branches

Glaze Burnt Sienna on the brownish parts of the branches, then shape them using a mixture of Indigo, Prussian Blue and Quinacridone Violet with a no. 8 round. Use less water with the pigment to intensify the edges and texture of the bark.

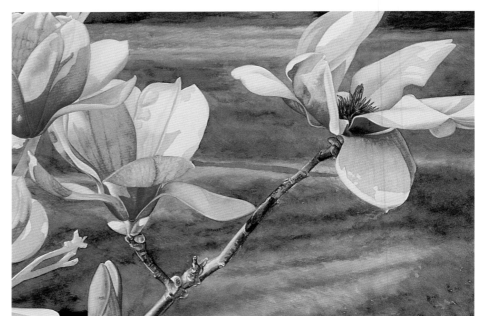

12 Color the Branches and Buds

Avoiding the highlights, glaze Sap Green on the greenish buds with a no. 8 round, then define them using the same brush with a dark mixture of Sap Green and Sepia. At this point, your palette contains many colors that you have used for the flowers, branches and background. Don't hesitate to use any color you want for the branches and buds since anything is possible in nature!

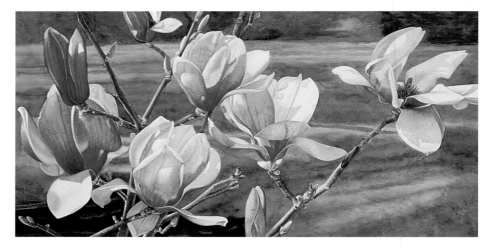

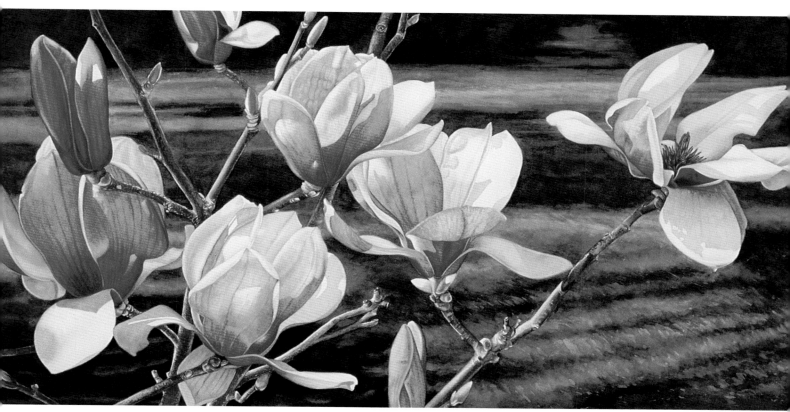

13 Finish the Painting

Add texture to the background with a mixture of Winsor Green (yellow shade), Indigo and Quinacridone Magenta. Pay particular attention to the direction of the background patterns, which create movement, and the darker green, which enriches the value of the painting. Use a no. 8 round to add the texture and complete the background. A small brush works much more efficiently to continue the direction of the patterns and add the texture behind the flowers and branches.

SPRING GREETING
15" × 30" (38cm × 76cm)
140-lb. (300gsm) cold-press Arches

Capture Mood With a Blue Undertone

Even with flowers, the feeling of a painting can range from happy to sad, quiet to loud, serene to chaotic. It is all up to you to portray the subject matter with different styles, colors, moods and attitudes.

This reference photo is nice because the flower sits very quietly with a warm, contented feeling. Do you see its quiet mood? It's interesting how many different feelings you can portray with just flowers. Feelings add power to your paintings. Infuse your subject with the quiet, shy, friendly mood of this peony.

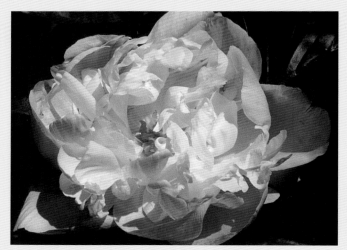

Reference Photo

Materials List

22" × 30" (56cm × 76cm) 140-lb (300gsm) cold-press Arches 🌼 3½-inch (89mm) Hake 🌼 Mechanical pencil 🌼 Nos. 10 and 12 rounds

Color Palette

Aureolin (Winsor & Newton) 🌼 Bamboo Green (Holbein) 🌼 French Ultramarine (Winsor & Newton) 🌼 Gamboge (American Journey) 🌼 Indigo (Holbein) 🌼 Permanent Alizarin Crimson (Winsor & Newton) 🌼 Permanent Rose (Winsor & Newton) 🌼 Prussian Blue (Daler-Rowney) 🌼 Quinacridone Magenta (Winsor & Newton) 🌼 Sap Green (American Journey) 🌼 Sepia (Holbein)

Drawing
This peony's many layers of petals with different shapes in all directions make it difficult to draw. Find the larger petals first and add the small petals as you draw. Missing a few petals won't change the mood, but missing many will distort the flower's shape. Two buds added to the left side of the peony make a better composition; the main peony will look less static and centered.

1 Apply the First Wash

To portray an overall quiet feeling, start with a light bluish wash over the entire painting area. Wet the paper with clean water, then apply a smooth, fast application of thinned French Ultramarine with your 3½-inch (89mm) hake. This thinned blue wash will calm the flower's overall feeling instead of creating one that is too bright and cheery.

2 Separate the Foreground and Background

Using a no. 12 round, glaze the center of the peony and wash the area surrounding the flower and buds with a thinned mixture of Gamboge and Aureolin.

3 Set the Highlights

Before detailing the petals, set the highlights of the flower. Wet the surface of the paper with your 3½-inch (89mm) hake, then apply a thin wash of Permanent Rose with the same brush. Concentrate the wash on the flower petals, though it naturally will spread throughout the surrounding space. The wet surface helps the pigment spread out smoothly. This thinned reddish wash might seem dark for the highlights, but let it dry and then be the judge!

4 Detail the Petals

Alternating between two no. 12 rounds—one to apply pigment and the other to blend—glaze Quinacridone Magenta for the base local color of the petals. Use a mixture of French Ultramarine and Prussian Blue for the bluish shadow and the highlights that reflect the surrounding colors. At this step, keep the glaze light. Don't try to finalize the glaze in one step. Continue working on all the petals.

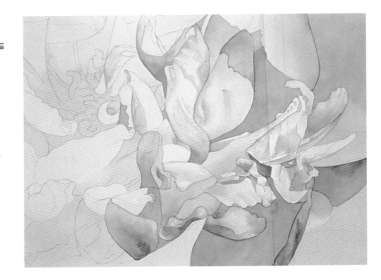

5 Finish the First Glaze

Using a no. 10 round, glaze a diluted mixture of Quinacridone Magenta and Prussian Blue on the shadow area to help form the flower. With your painting on the easel, step back five to ten steps and squint to study the values. You want to avoid having dark values in sunlit areas.

Add a little bud to the top left corner of the flower. This element breaks up the large blank background for a better composition.

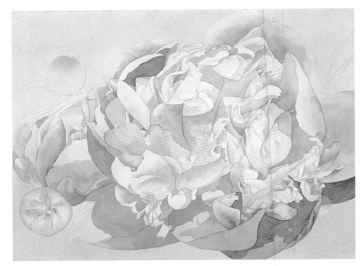

6 Develop the Petals

Continue developing your petals with Quinacridone Magenta, French Ultramarine and Prussian Blue using a no. 10 round. Use a thinned mixture of Prussian Blue and Quinacridone Magenta (mostly Prussian Blue) for the shadow, and in opposite proportions for the light reddish hue of the petals.

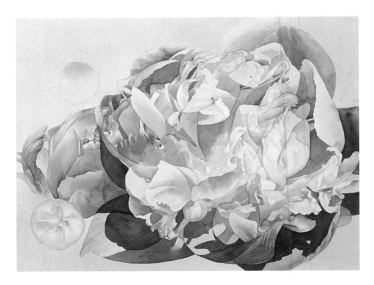

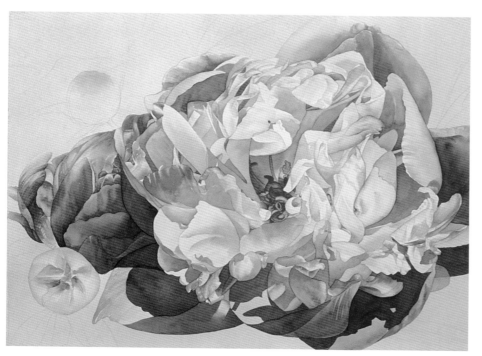

7 Detail the Center and Darken the Values

With Permanent Rose, develop the center of the flower. Because it's so detailed, use a no. 12 round with a pointy tip or a smaller brush.

Continue developing buds with the same hues as the main flower, but use darker values to separate them from the main flower. At this point, you also should develop the petals in the darker areas. Don't worry about the value being too dark on the bottom and outer petals: The value of the subject will appear to change dramatically with lighter or darker backgrounds, and you can always correct it later.

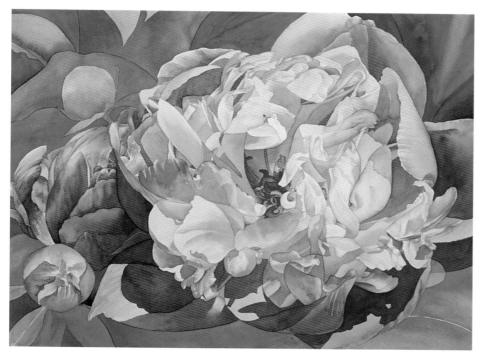

8 Glaze the Leaves

Glaze a mixture of Bamboo Green, Sap Green and Permanent Alizarin Crimson on the leaves using a no. 12 round. This application is the second undercoat of the leaves. This green hue makes the leaves naturally recede into the background, pushing the flower into focus. Let it dry.

9 Define the Leaves

Using a no. 12 round, glaze premixed Indigo, Prussian Blue and Sepia over your existing layers to define the veins of the leaves and break up the solid, dark background. For a cooler dark green, mix Indigo and Bamboo Green with a touch of Permanent Alizarin Crimson. For more warmth, mix Bamboo Green, Alizarin Crimson and Sepia.

For the lighter areas of the leaves, mix Sap Green, Bamboo Green and a little Indigo or Sepia, depending on the temperature you wish to portray.

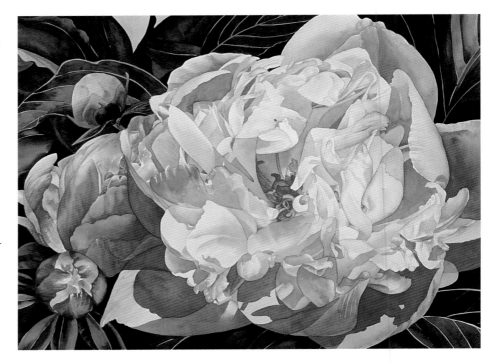

10 Detail the Leaves

Using Bamboo Green, Alizarin Crimson and either Indigo or Sepia (depending on the temperature you'd like), define the shapes of the leaves with a no. 10 round. Lift off some of the dark hues for highlights with a bristle brush and, if needed, darken the veins to match the value of the leaves.

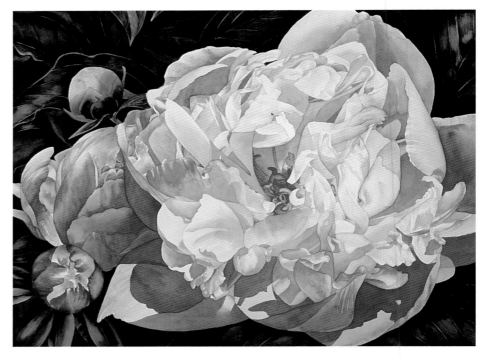

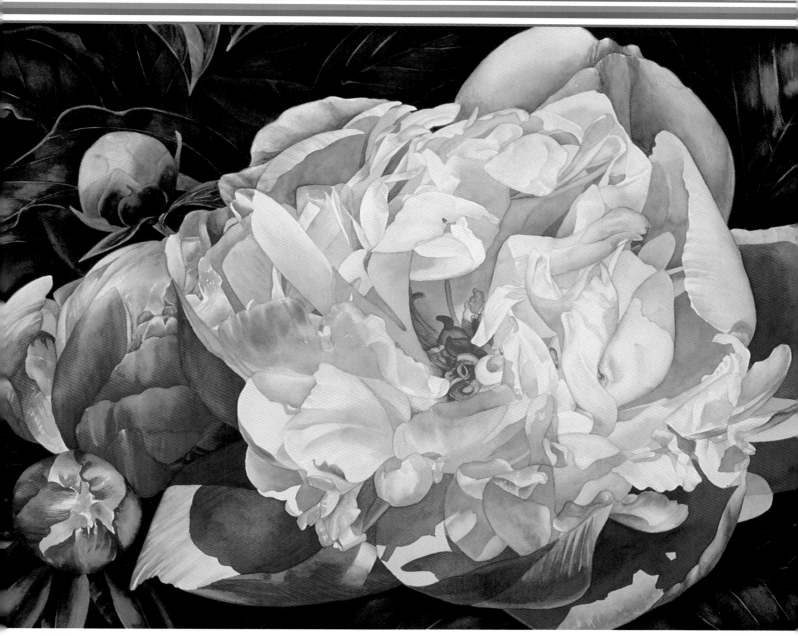

11 Add the Final Touches

Finalize the flowers by glazing on a mixture of Quinacridone Magenta and Indigo wherever you want the darkest value of the shaded areas with a no. 10 round. The amount of final detail is a personal choice, so continue until you feel pleased. This light, bluish peony awaits a sunny day with shy, open arms.

PEONY IN THE MORNING
21" × 31" (53cm × 74cm)
140-lb. (300gsm) cold-press Arches

BOUGAINVILLEA

Create Exciting Contrast

Straying from harmonious colors can lead to exciting and brilliant results. This scraggly bougainvillea bush against a yellow wall caught my eye as I was running late returning to a cruise ship in Panama. The reference photo, taken on the run, turned out beautifully.

The contrast between the greenish yellow background and bright blue-magenta bougainvillea is exciting. The stark contrast is subdued by the earthy tone of the shadows on the yellow wall.

If you want to keep the flowers a crisp, sharp magenta, applying an undercoat of yellow won't work. There are two good solutions. You can paint the background section by section, avoiding the flowers and branches, or apply masking fluid to the flowers and branches and apply a yellow wash over the entire composition. There are pitfalls with either option, but I chose to paint each part separately.

Materials List

22" × 30" (56cm × 76cm) 140-lb. (300gsm) cold-press Arches ❈ Mechanical pencil ❈ Nos. 8, 10 and 12 rounds ❈ Masking fluid ❈ Rubber cement pickup ❈ Sponge ❈ Toothpick

Color Palette

Aureolin (Winsor & Newton) ❈ Bamboo Green (Holbein) ❈ Gamboge (American Journey) ❈ French Ultramarine (Daniel Smith) ❈ Indigo (Holbein) ❈ Prussian Blue (Daler-Rowney) ❈ Permanent Rose (Winsor & Newton) ❈ Quinacridone Magenta (Winsor & Newton) ❈ Sepia (Holbein)

Reference Photo

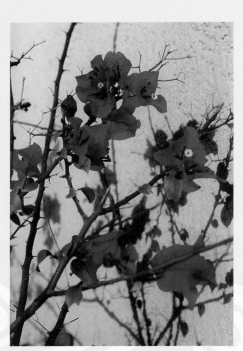

Drawing
Draw the outlines of the flowers and branches, and indicate the cast shadows on the wall.

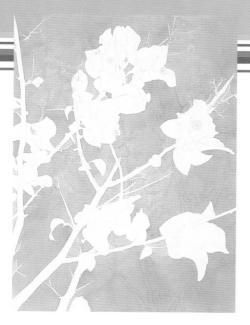

1 Begin the Background

The big branch on the left side doesn't do anything for the composition, so erase it completely. Mix a base hue of Aureolin with a touch of Bamboo Green and Indigo on your palette. This combination lacks warmth, so add Gamboge, a warm and slightly reddish yellow color.

Apply masking fluid on the thin branches and stigma with a toothpick. Using a no. 12 round, start painting the background wet-into-wet, including the shadowed areas. Be sure to use plenty of paint to help avoid hard edges.

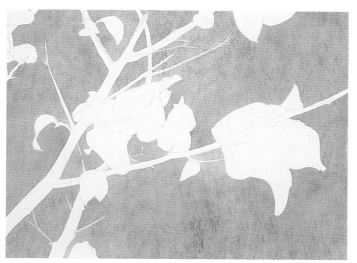

2 Add Texture to the Stucco

Using a sponge, gently tap the surface of the wall with diluted French Ultramarine. Gently tap the sponge in one direction, avoiding the flowers. If some texture hits the flower, it's okay—the thinned blue is light enough not to show up.

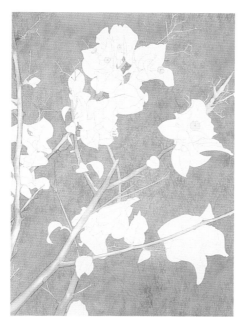

3 Retouch the Wall

If the overall look of the background wall is too greenish after the stucco dries, apply one more wash of Gamboge to increase the yellowish tone. After it dries, remove all the masking fluid from the branches with your fingertip. Next, use a no. 12 round to glaze diluted Prussian Blue onto the edge of the branches. Use a no. 10 round with clean water in the middle of the branch to lighten the color and evenly distribute it.

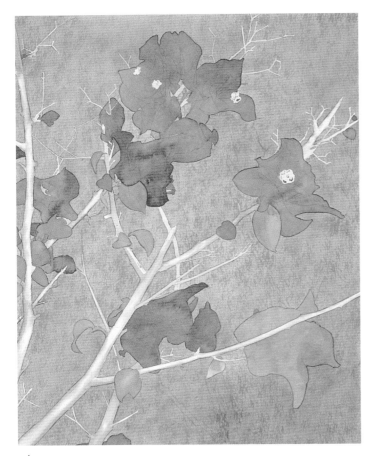

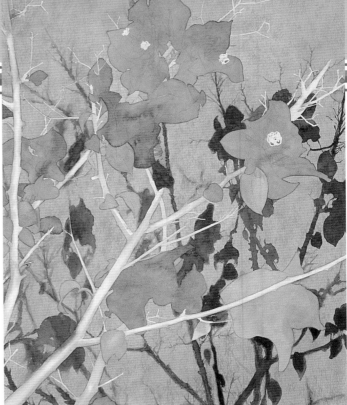

5 Define the Shadows

Mix Sepia, French Ultramarine and Quinacridone Magenta on your palette to make the cool reddish brown you want for your cast shadows. Apply this uniformly with a no. 12 round, then blend and feather out some of the edges to soften the shadows while the pigment is still wet.

4 Glaze the Flowers and Leaves

Glaze premixed Quinacridone Magenta and French Ultramarine onto your flowers using a no. 12 round. Using a no. 10 round, glaze Bamboo Green onto the leaves. At this point, don't worry about defining depth.

6 Add Depth to the Flowers and Branches

To make deeper, richer flowers, apply a second glaze of premixed Quinacridone Magenta and French Ultramarine using a no. 12 round. Glaze Prussian Blue onto the branches with the same brush. Adding color to the branches at this point brings all of the elements to similar overall values, which emphasizes the contrasts.

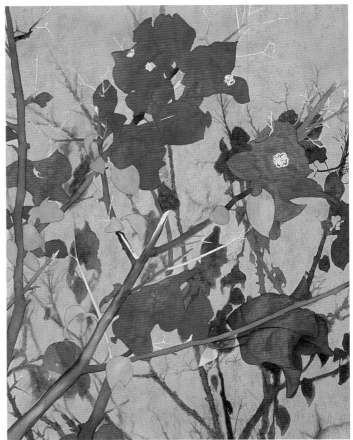

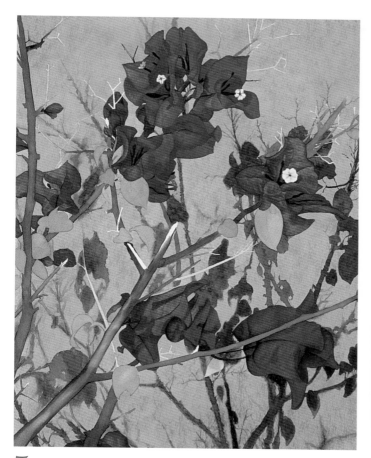

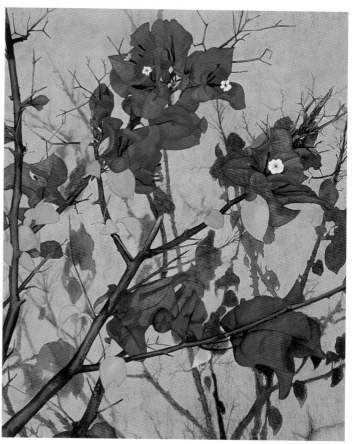

7 Define the Flowers

Alternating nos. 8 and 10 rounds, glaze a deeper value onto the flowers with French Ultramarine and Quinacridone Magenta. Where the flower is reddish, glaze Permanent Rose. Add Sepia to the stamen and veins to darken them. The areas on the flowers left untouched will act as your lighter values. Remove the masking fluid from the stigma using rubber cement pickup, and define it with Quinacridone Magenta.

8 Define the Branches

Using a no. 10 round, define the thicker branches. Use a no. 8 round with a fine point for the twigs. For the lightest parts of the branches, glaze French Ultramarine and Quinacridone Magenta using a no. 8 round. Add a mixture of Prussian Blue and Sepia for the darkest parts with the same brush.

9 Detail the Flowers and Branches

Alternating nos. 8 and 10 rounds, finalize the flower petals with a mixture of Quinacridone Magenta and French Ultramarine to create the crease and lighter shadows. Using a no. 10 round, glaze Permanent Rose onto the reddish parts of the flowers. For the shadow area, add a little Sepia to the Permanent Rose on your palette.

To create the vein, use Sepia on the tip of a no. 8 round to make narrow lines. Use the same color and brush to finish the stamen. For the branches, mix French Ultramarine and Quinacridone Magenta and glaze the lighter parts. Using premixed Prussian Blue and Sepia and the same brushes, drybrush the darkest parts of the branches.

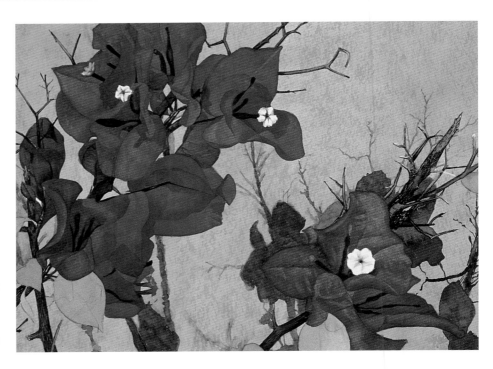

10 Glaze the Leaves

Mix Bamboo Green, Sepia and Permanent Rose on the palette and glaze the leaves to create a darker value. Apply the mixture with a no. 8 round; then blend and feather it out with a clean, wet no. 8 round.

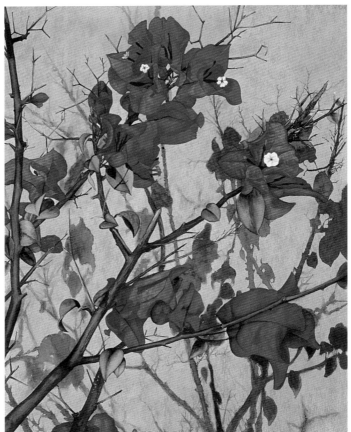

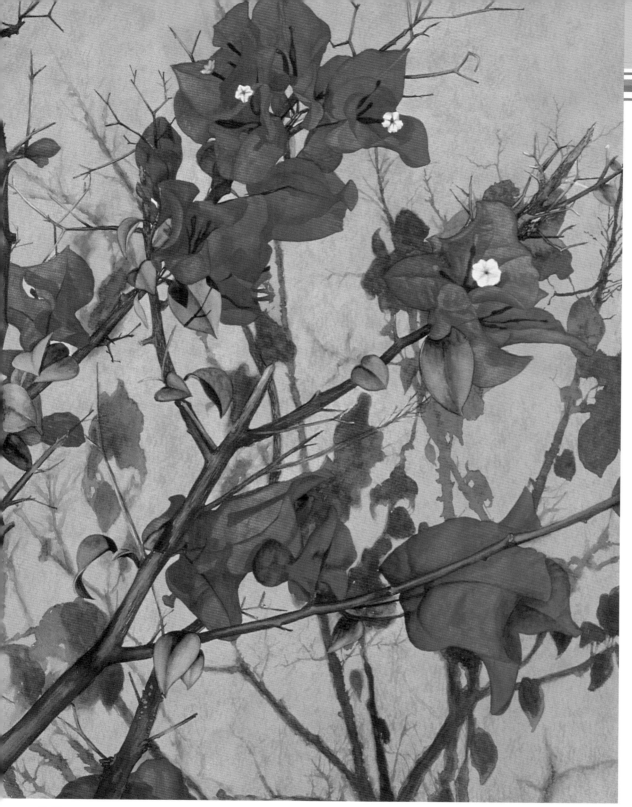

11 Finish the Painting

Decisions about the final-touch ups of the branches, flowers and shadows are all up
to you. I used the leftover shadow mixture to darken some of the shadows and, using
a drybrush technique, created a bark texture on the thick branches.

The dark branches and odd contrast of yellow and magenta create interesting
patterns that convey feelings of restlessness on a bright sunny day.

Use Gold Powder to Add Light

Painting flowers using the color scheme of their natural, outdoor setting is generally simple and predictable. However, experimenting with lighting in a designed setting can bring out interesting, exciting and unexpected compositions and moods.

Introducing gold powder can create a fun and original painting, as well as add light where it's lost in dark pigment. The light reflected by gold powder is different from the light reflected by white paper highlights. Gold powder reflects and refracts light from the surrounding colors. The effect changes as you view the painting from different angles. Light reflected by paper is sharper, but doesn't change at different angles.

This narcissus snuggled in an unconventional glass looks interesting and fun. The background enhances the flowers, making them appear to float under the sweeping motion. The color reflections from the cloth are under and beside the glass. They create an effect that would be hard to capture using traditional paper highlights.

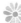 **Materials List**

15" × 22" (38cm × 56cm) 140-lb (300gsm) cold-press Arches ❀ 3-inch (76mm) Hakes ❀ Acrylic Matte Medium (Golden) ❀ Masking fluid ❀ Nos. 8, 10 and 12 rounds ❀ No. 2 script liner ❀ Rich Pale Gold Powder (Schmincke) ❀ Toothpick

 Color Palette

Aureolin (Winsor & Newton) ❀ Bamboo Green (Holbein) ❀ Burnt Sienna (Winsor & Newton) ❀ French Ultramarine (Winsor & Newton) ❀ Gamboge (American Journey) ❀ Indigo (Holbein) ❀ Permanent Alizarin Crimson (Winsor & Newton) ❀ Permanent Rose (Winsor & Newton) ❀ Prussian Blue (Daler-Rowney) ❀ Sepia (Holbein)

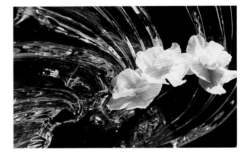

Reference Photo

Drawing
Draw the larger shapes and lines of the glass—detailing it right now is impractical. You want to draw based on what you feel instead of merely following the lines. Just draw a basic outline of the larger shapes and flower petals.

1 Apply Masking Fluid and the First Wash

Using a toothpick, apply masking fluid to your white highlights to preserve them. After it dries, wet the surface of the paper with clean water. Wash with a diluted mixture of Gamboge and Aureolin using a 3-inch (76mm) hake.

2 Glaze the Background With Yellow

Using a no. 12 round, glaze a mixture of Gamboge and Aureolin onto the reflected highlights of the background. This yellow is part of the highlights that will show through in the final painting.

3 Glaze the Background With Blue

Using your no. 12 round, glaze French Ultramarine over the lines at the bottom of the composition. Next, add a little Permanent Rose to the French Ultramarine on the palette to create a warmer, purplish blue, and glaze it onto the lines at the top of the painting. While making these applications, maintain the circular, fanning motion of the background.

4 Apply a Red Glaze to the Reflection

Using a no. 12 round, glaze Permanent Rose onto the background strips that reflect a reddish hue. Don't worry if these reddish strips are too wide—any extra will be covered with dark pigment to make the proper width in the final detailing process. In fact, it's better to make them too wide instead of too thin.

5 Glaze the Background and Flowers

Using a no. 12 round, glaze diluted Prussian Blue onto the darkest area of the background. At this point, the multiple hues in the background should overlap loosely. Next, glaze Aureolin over the lighter petals and Gamboge onto the center of the flowers with a no. 12 round. Let the paint dry.

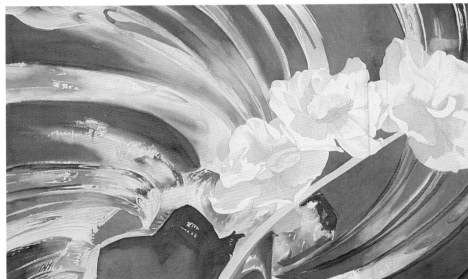

6 Detail the Flowers

Using a no. 12 round with a pointy tip, glaze a mixture of Permanent Rose and Gamboge to create the orange hue at the center of the flowers. Then separately glaze Burnt Sienna and Prussian Blue over the dark shadow on the petals. This makes a muddy, dull color for the shadow instead of a bright, clean greenish or purplish color. For the light petals, mix Prussian Blue with Aureolin and apply a very light green glaze with a no. 10 round.

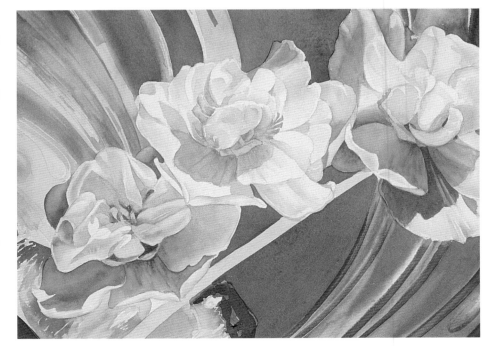

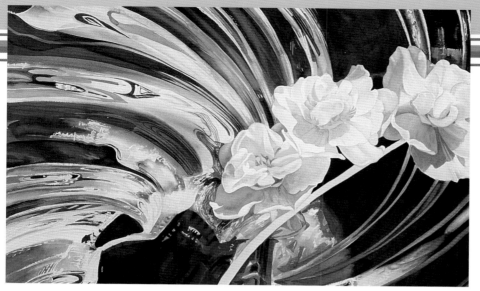

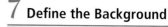

7 Define the Background

Start to define the dark reflection in the background with a mixture of Indigo, Sepia and Permanent Alizarin Crimson. For the big, wide areas, use a no. 12 round. A no. 8 round works nicely for the narrow areas. Be sure to save the highlights and lighter parts of the background for later details. Your flowers should start to stand out from the background in an interesting contrast.

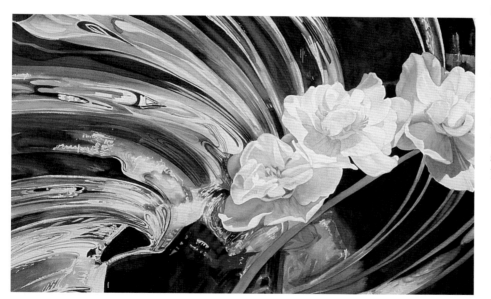

8 Begin the Stem

Using a no. 12 round, glaze Bamboo Green onto the flower's stem and spread it into the background reflection. This strong, bright green will show through later applications.

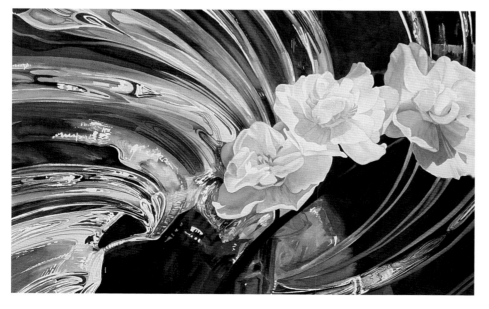

9 Complete the Stem

Darken the value of the stem using a no. 8 round with a mixture of Indigo, Sepia and Permanent Alizarin Crimson. Then use your fingertips to remove the masking fluid covering your highlights before starting the details of the background.

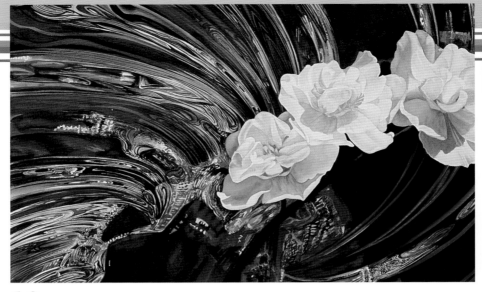

10 Finish the Background

Finalizing the background requires using all the hues in the image: Aureolin, French Ultramarine, Prussian Blue, Indigo, Permanent Alizarin Crimson, Permanent Rose, Gamboge, Sepia and Bamboo Green. To define the lines, use a no. 2 script liner. Concentrate on the direction of the curves. Glaze premixed Indigo, Sepia and Permanent Alizarin Crimson onto the darkest curves. Keep enough moisture in the brush for sharp, continuous, one-stroke application. You could stop at this point, but one more step completes the painting in a unique, exciting way.

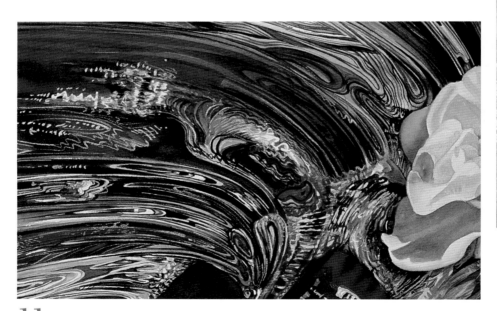

11 Apply the Gold Powder

Using a no. 2 script liner, draw highlight lines with a mixture of acrylic Matte Medium and gold powder next to the colored lines in the background. To draw a clean, one-stroke line, use a brush fully loaded with the powder. The lines will be choppy if you use multiple brushstrokes. Using water alone won't bind the gold powder to the paper, so use an equal mixture of medium and clean water. The gold powder will not overpower the painting, just make the lines shine subtly with glitter.

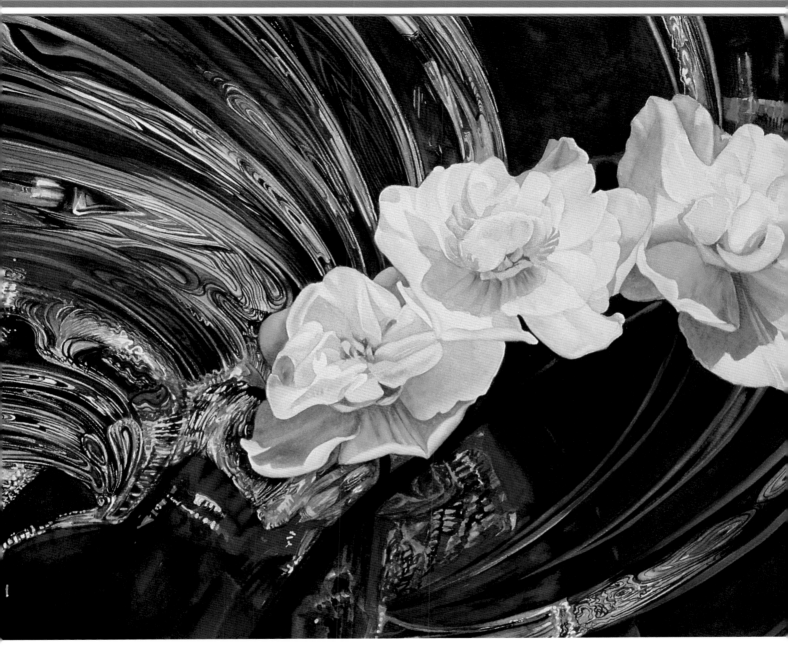

12 Finish the Painting

Finish the painting by cleaning up your brushstrokes and making sure the surface of the glass is as smooth as it should be. The blossoms should glow against this interesting, multi-colored background. The application of the gold powder enhances the colors and makes the painting glow. It's worth the extra effort!

MILKY WAY
15" × 22" (38cm × 56cm)
140-lb. (300gsm) cold-press Arches

Depict Textures and Reflections

Metals can introduce new and exciting elements into your work. Each has its own characteristics that set it apart and challenge you as an artist. For example, in normal lighting conditions, shiny stainless steel has a cold, silvery surface and dark gray shadows. Rusted iron is a deep reddish brown, brass is a light greenish yellow and copper is a light reddish brown. These colors change depending on whether the surface is polished or old and corroded.

Check out antiques malls or garage sales for odd and interesting objects to use as backdrops for your flowers. This tarnished copper vase, found at an antiques store, instantly attracted me. The yellow rose naturally harmonizes with the reddish copper.

Materials List

22" × 30" (56cm × 76cm) 200-lb (425gsm) cold-press Waterford ❋ Mechanical pencil ❋ Nos. 8, 10 and 12 rounds ❋ No. 2 script liner ❋ Rich Pale Gold Powder (Schmincke)

Color Palette

Aureolin (Winsor & Newton) ❋ Bamboo Green (Holbein) ❋ Burnt Sienna (Winsor & Newton) ❋ French Ultramarine (Daniel Smith) ❋ Gamboge (American Journey) ❋ Permanent Alizarin Crimson (Winsor & Newton) ❋ Prussian Blue (Daler-Rowney) ❋ Quinacridone Burnt Orange (Daniel Smith) ❋ Scarlet Lake (Winsor & Newton) ❋ Sepia (Holbein)

Drawing
Draw the outline of the petals, vase and larger shadows with a mechanical pencil.

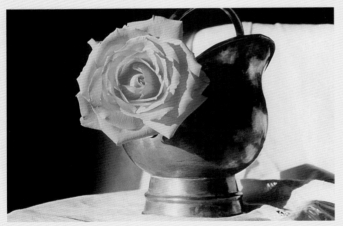

Reference Photo

1 Add Texture to the Background

Apply an initial wash of Gamboge and Aureolin using a no. 12 round, then begin adding texture to your background by detailing the cloth and breaking up the two contrasting blank spaces. Also, extend the cloth to the top of the right side.

Use a mixture of gold powder and diluted Matte Medium to draw the background design with a no. 2 script liner. The gold powder resists water, so the design will show through even after adding layers of glaze.

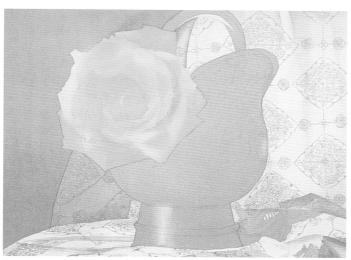

2 Glaze the Flower and Vase

Apply a thinned glaze of Aureolin on the entire flower using a no. 12 round. After it dries, apply Quinacridone Burnt Orange on the copper vase. The base of the vase is lighter than the rest of it, so be sure to preserve your highlight there. Apply any leftover Quinacridone Burnt Orange to the cloth in the background to begin building up the dark final value.

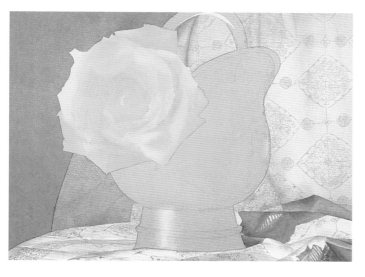

3 Appraise the Temperature

Before developing the petals, the overall reddish hue needs to be cooled. Using a no. 12 round, glaze thinned French Ultramarine on the background and cloth. Apply a darker value to the shadow with the same brush. This makes the background calm and uniform, which allows your rose to shine.

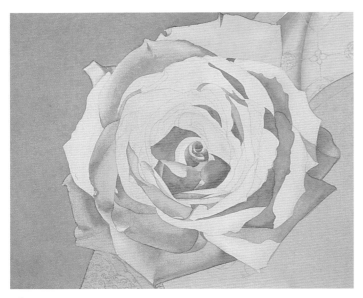

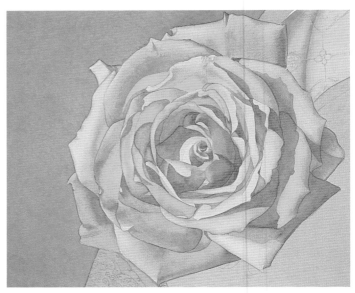

4 Define the Petals

Glaze each rose petal with Scarlet Lake for the reddish area and Gamboge for the lighter parts. Study each petal shape in the reference photo to determine your values, and blend the colors with a clean brush. Use three brushes: a no. 12 round for Scarlet Lake, a second no. 12 round for Gamboge and a no. 10 round for blending.

5 Add Depth to the Rose

The first glaze creates the rose, but it lacks depth. In this step, concentrate on building up the color with glazes of Scarlet Lake and Gamboge using the same three brushes as you did in the previous step.

6 Finish the Flower

Mix Sepia with Scarlet Lake on your palette for the darker areas of the petals. Use a drybrush technique to define the wrinkles with a no. 8 round or any small brush that you're comfortable with.

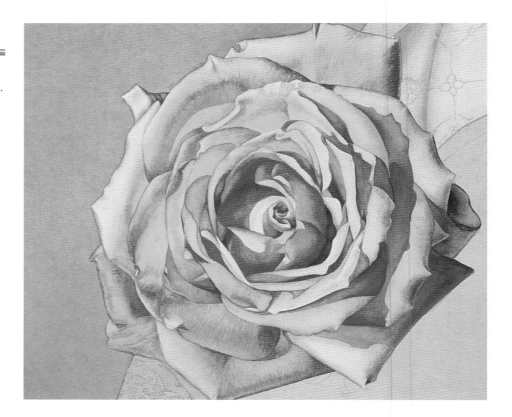

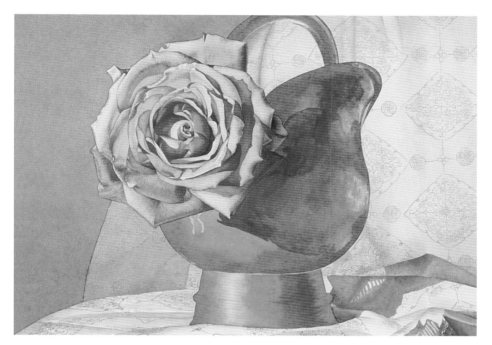

7 Apply Local Color to the Vase

Glaze a reddish copper color onto your vase using a mixture of Permanent Alizarin Crimson and Burnt Sienna with a no. 12 round. Soften the hard edges by running a damp brush across them from darker areas toward lighter areas.

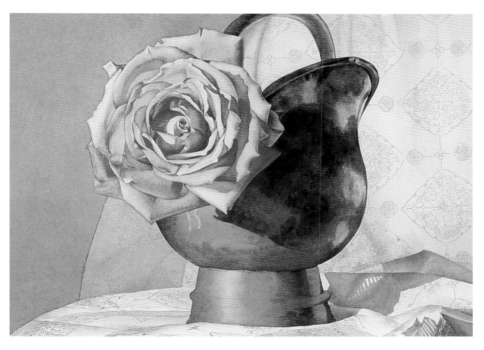

8 Detail the Vase

Using a no. 12 round, glaze thinned Prussian Blue over the vase to calm the reddish tone. When the surface is damp—but not wet—start to develop it. Some spots will dry out during the process, which is an ideal condition because some hard edges are necessary.

Using a drybrush technique with a worn no. 12 round or flat brush, apply a dark mixture of Permanent Alizarin Crimson and Sepia for the mid-value texture. Dragging pigment with a dry brush lets the reddish hue of the under-coat show through.

9 Finish the Vase

To prevent hard edges, apply Bamboo Green and Prussian Blue wet-into-wet to the darkest shadows while the surface is still damp using a no. 12 round. Spread out the pigment with a dry brush for an obvious hard edge. Continue to develop the details of the vase. Any excess green and blue takes on the look of oxidation on the copper base.

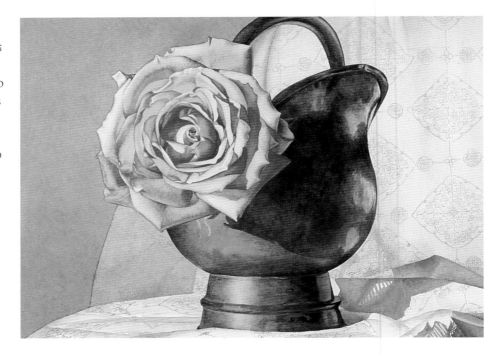

Potluck Background

"Potluck Background" is just a fun term I use that means mixing all the leftover colors in the palette to make a dark background. To make a dark and solid background, it is important to avoid all colors containing yellow: yellow, yellow-green, yellow-orange, orange and red-orange.

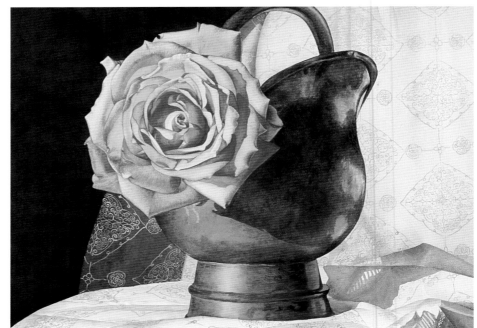

10 Paint a Potluck Background

Add more Permanent Alizarin Crimson, Bamboo Green, Prussian Blue, Sepia and some water to your palette to make a dark color. Apply this dark mixture to the left side of the background.

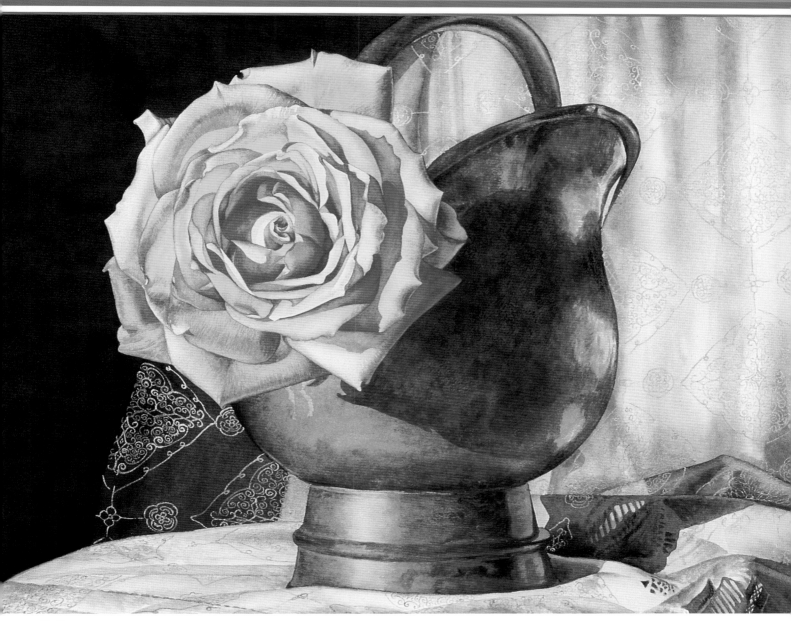

11 Finish the Painting

Let the background dry, then use your no. 12 round to darken it with another layer
of the potluck mixture. On the second application, apply it heavily to the left side of
the cloth, where the shadow falls.

After this step, it would be fine to leave the background as is, but there's still room
for improvement. Adding a crease to the fabric will break up the background and
help make your subject stand out. Change directions! Wet the background cloth
first, and then apply some of the potluck mixture vertically to give the impression
of sheer cloth. After it dries, develop the foreground cloth with the same color to
finalize it.

YELLOW AND COPPER
21" × 29" (53cm × 74cm)
200-lb. (425gsm) cold-press Waterford

Paint Backgrounds That Glow

When you find an interesting subject in a long, horizontal format, you might consider creating or seeking out an exceptional background. A vine following a fence or wire is a great example. A vine makes for an airy, spacious subject and creates a calm and tranquil feeling.

In this demonstration, you will learn how to create a background that glows, allowing the subject matter to stand out. To create the glowing effect, a yellow undercoat is essential. Without a yellow undercoat, the background just ranges from a light value to a dark value with no warm, glowing effect.

Before beginning this exercise, stretch your paper on a board. The wash for this painting will not work properly on unstretched paper, especially if it's watercolor paper that is less than 140 lb. (300gsm). Also, be sure to keep plenty of hakes on-hand—they take a long time to dry out, and dry ones are essential for blending because a wet hake will produce blossoms and uneven colors.

For this painting, you'll need to use liquid acrylic, specifically Quinacridone Burnt Orange from Golden Fluid Acrylics. Acrylic paint creates a waterproof barrier: It won't lift off the paper as easily as watercolors will. When there are more than five washes involved, a layer of acrylic can be used as a safety net over the previous watercolor washes. You can use the same brushes and paint in the same manner as you do with watercolors, but be sure to rinse the brush as soon as you finish an application so the acrylic doesn't dry and ruin the brush.

Materials List

22" × 30" (56cm × 76cm) 140-lb. (300gsm) cold-press Arches ❈ 3½-inch (89mm) and 2-inch (51mm) hakes ❈ Masking fluid ❈ Masking tape ❈ Mechanical pencil ❈ Nos. 6, 8, 10 and 12 rounds ❈ Rubber cement pickup ❈ Toothpick

Color Palette

Watercolors ❈ Aureolin (Winsor & Newton) ❈ Bamboo Green (Holbein) ❈ Cadmium Red Purple (Holbein) ❈ Gamboge (American Journey) ❈ Prussian Blue (Daler-Rowney) ❈ Quinacridone Burnt Orange (Daniel Smith) ❈ Quinacridone Gold (Winsor & Newton) ❈ Sap Green (American Journey) ❈ Scarlet Lake (Winsor & Newton) ❈ Sepia (Holbein)

Acrylics ❈ Quinacridone Burnt Orange (Golden Fluid Acrylics)

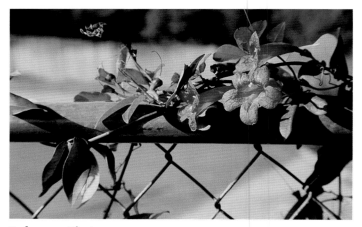

Reference Photo

Drawing
Outline the subject on your paper.

1 Lay the First Wash

Wet the surface of your paper and apply a wash of Aureolin with a 3½-inch (89mm) hake. Concentrate on the top and bottom. When it's dry, apply masking fluid to the centers of the flowers with a toothpick. When the masking fluid is dry, lay a wash of Gamboge onto the wet paper with a 3½-inch (89mm) hake.

2 Add More Color

Using a 3½-inch (89mm) hake, gently apply Quinacridone Burnt Orange (the watercolor) to the top and bottom of the painting. Feather toward the center to create a smooth transition to the lighter colors with a dry 2-inch (51mm) hake. Remember that rubbing too hard with the brush will result in scrubbing off some of the previous wash.

3 Cool the Background

Wash Prussian Blue over the background with a 3½-inch (89mm) hake. This blue layer will cool down the reddish Quinacridone Burnt Orange.

4 Create Depth

The background needs a deeper value after the initial application of Prussian Blue, as well as more yellow hue to further the glowing effect. After the Prussian Blue has completely dried, gently wet the paper with clean water and wash with Quinacridone Gold using a 3½-inch (89mm) hake.

5 Switch to Acrylics

To darken the background but avoid
lifting colors from later washes, change
from watercolor pigment to liquid
acrylic. Wet the surface of the paper and
wash it with Quinacridone Burnt
Orange (the acrylic) using a 3½-inch
(89mm) hake. Apply the pigment more
thickly on the top and bottom of the
painting and, using a dry 2-inch
(51mm) hake, feather the edge of the
top and bottom gently into the middle.

6 Mind Your Values

Wait until the acrylic layer is completely dry, and it will form a
seal over the first few watercolor washes. Then wash a mixture
of Sepia and Prussian Blue on the top and bottom of the
painting using a 3½-inch (89mm) hake to create the darker
values. Use a dry 2-inch (51mm) hake to feather.

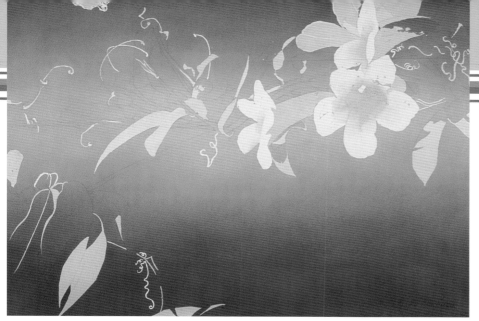

7 Remove the Masking Fluid and Apply a Yellow Undercoat

Removing the masking fluid makes your flowers stand out from the background. Use rubber cement pickup for the larger areas, and run a fingertip over the painting to be sure you didn't miss any of the smaller spots.

Add your yellow undercoat to the flowers by glazing Gamboge over the center of the flowers and leaves with a no. 10 round. Glaze Sap Green onto the leaves with the same brush.

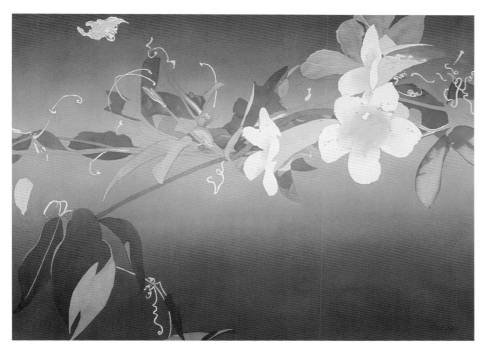

8 Apply Color to the Flowers

Using a no. 10 round, glaze Cadmium Red Purple onto the flowers and buds. Be sure to save the highlights.

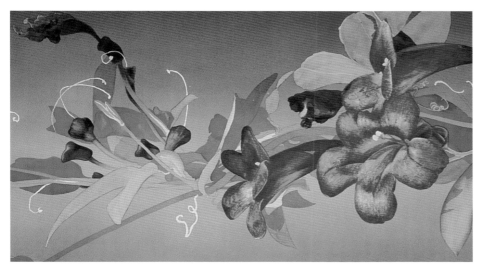

9 Define the Flowers

Alternating nos. 10 and 12 rounds, define the flowers and buds one by one. Glaze Cadmium Red Purple onto the buds. On the flowers, apply a mixture of Scarlet Lake and Cadmium Red Purple. Glaze the pigment carefully on the petals and buds to save your highlights. Mix Cadmium Red Purple and Sepia and apply the mixture to the blossoms with a no. 10 round.

10 Define the Vine and Wire

Using the same colors as you did for the flowers (Scarlet Lake, Cadmium Red Purple and Sepia), glaze the barbed wire and vine with a no. 8 round. Glaze Sap Green to create the greenish part of the vine.

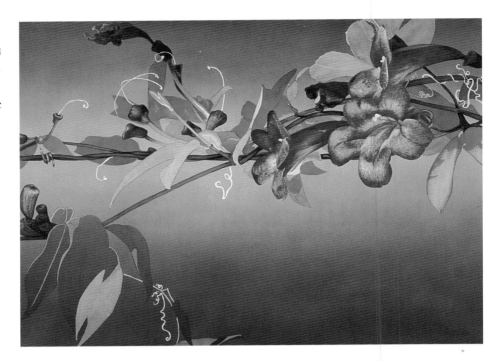

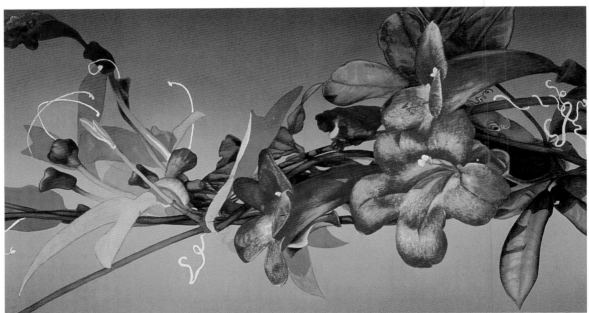

11 Define the Leaves

Using a mixture of Sap Green, Bamboo Green, Cadmium Red Purple and Sepia, glaze the darker leaves with a no. 10 round. For the lighter leaves, glaze a thinned mixture of Sap Green and Sepia. After the lighter leaves dry, darken the shadow with Bamboo Green and Sepia. Applying a touch of Cadmium Red Purple in the shadows with a no. 10 round will bring the darkness to life.

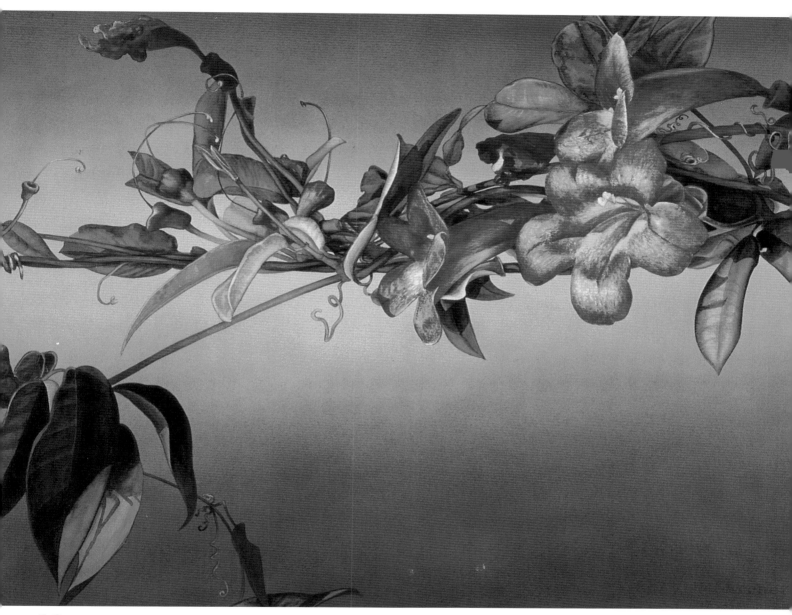

12 Finish the Painting

Use a no. 6 round with a very fine point to draw lines on both edges of the stigma with a mixture of Cadmium Red Purple and Sepia. Then, with a clean, damp no. 6 round, blend toward the center of the stigma to smooth it out.

CROSS VINE
22" × 30" (56cm × 76cm)
140-lb. (300gsm) cold-press Arches

Create Deep, Saturated Color

Generally, watercolor paintings look lighter and airier than oil paintings. That doesn't mean you can't apply deep, dark saturated colors. Zinnia petals call for a range of color, from light to dark velvety red, and you certainly can create it with watercolor.

Most flowers come and go within a week or so of the start of fall, but the zinnia blooms and blooms until the frost comes. It's one of the easiest flowers to grow, producing prolific, brilliant, velvety flowers without any effort. Zinnias also re-seed themselves and return each spring. This sun-loving, carefree flower produces abundant blossoms for your table and plenty to share with your neighbors, too. Of course, they're also great to paint!

 Materials

* 15" × 22" (38cm × 56cm) 140-lb. (300gsm) cold-press Arches ❋ Mechanical pencil ❋ Nos. 6, 8, 10 and 12 rounds

 Color Palette

Burnt Sienna (Winsor & Newton) ❋ Cadmium Yellow Deep (Holbein) ❋ Gamboge (American Journey) ❋ Indigo (Holbein) ❋ Permanent Alizarin Crimson (Winsor & Newton) ❋ Prussian Blue (Daler-Rowney) ❋ Quinacridone Magenta (Winsor & Newton) ❋ Sap Green (American Journey) ❋ Scarlet Lake (Winsor & Newton) ❋ Sepia (Holbein)

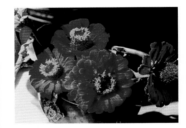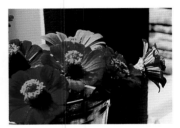

Reference Photos
Zinnia reference photos can be complicated. In the garden, the flowers are scattered randomly. In a vase, they tend to flop around. Balancing the composition in this painting requires combining two reference photos. When combining photos, remember to look for the same lighting direction and interestingly shaped flowers to fill the empty spaces.

Drawing
Outline the flowers, carefully studying the details. The dark and saturated colors of the zinnia make distinguishing individual petals difficult. Instead of trying to figure out the details later with a brush in your hand, study the structure of flowers now so you can create a drawing with greater detail.

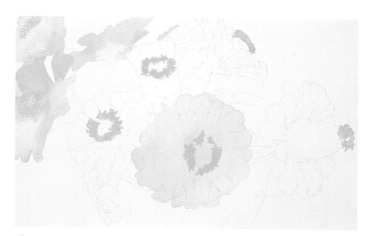

1 Apply a Yellow Undercoat to the Flowers

Using a no. 10 round, glaze Gamboge onto the flowers for a yellowish tone and Cadmium Yellow Deep onto the center of the stamen.

(I added another flower here—I noticed a slight imbalance in the composition, and the extra flower helps correct it.)

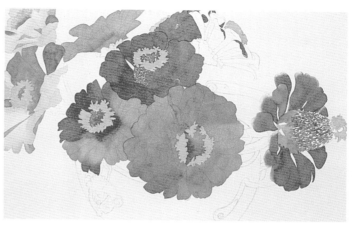

2 Apply a Red Undercoat to the Flowers

Glaze Scarlet Lake onto individual petals as needed to develop the different intensities of red. To create the darker red, use thick pigment with a no. 10 round. For the lighter red, use the same brush without dipping it into the pigment. Just use more water to dilute what's already on the brush.

Instead of using masking fluid, apply Scarlet Lake using choppy brush strokes to save the highlights in the seed pod area.

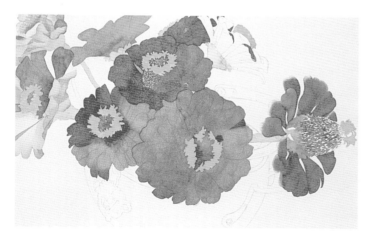

3 Apply More Yellow

Wash a mixture of Cadmium Yellow Deep and Gamboge over the flowers once more with a no. 10 round to make them a deep, rich red. Since it is hard to measure how many layers of undercoat will be needed to create the desired intensity, repeat the process until you find a color you like.

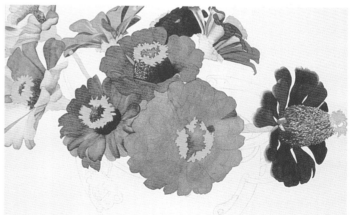

4 Develop the Flowers

Using three different no. 10 rounds, glaze Permanent Alizarin Crimson onto the deeper red petals, Quinacridone Magenta for a tint of bluish red on their highlights, and Gamboge on the yellowish flowers. Lift off some of the pigment where lighter color is needed before applying the Quinacridone Magenta.

5 Begin Developing the Background

Glaze Burnt Sienna onto the vase. After it dries, flat wash diluted Prussian Blue wet-into-wet onto the background using a no. 10 round.

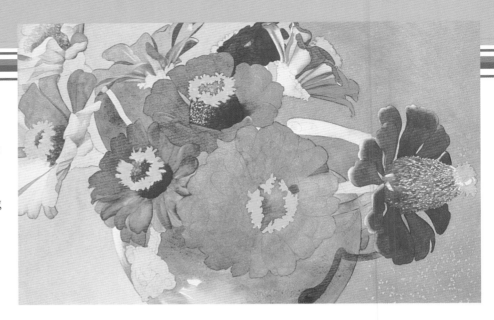

6 Build Up the Background

Developing the background makes the value of the subject much easier to read and correct. To avoid being stuck with an undesirable, strong color, use several thin layers of color instead of a strong, deep color all at once. Using a no. 10 round, add a layer of Prussian Blue or a deeper blue to the background and Permanent Alizarin Crimson onto the vase. Paint around the highlight on the vase to save it, then glaze diluted Permanent Alizarin Crimson onto it to reflect the red flower.

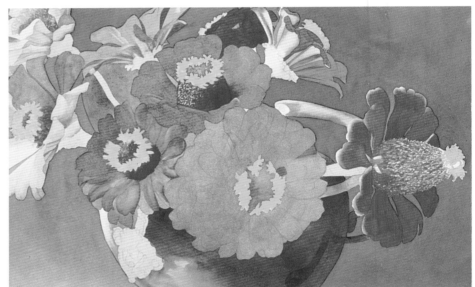

7 Detail the Vase

To create a dark, almost black color, mix Sepia, Indigo and Permanent Alizarin Crimson. Glaze it onto the vase with a no. 10 round. Glaze a thin coat of Permanent Alizarin Crimson as needed for the reddish copper color and warmer dark areas.

Glaze Gamboge onto the decoration at the end of the handle with a no. 10 round to cool its value, and define its details with the Sepia, Indigo and Permanent Alizarin Crimson mixture.

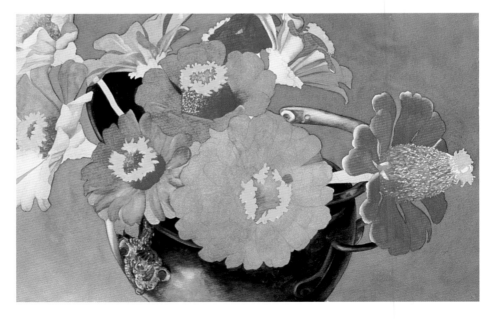

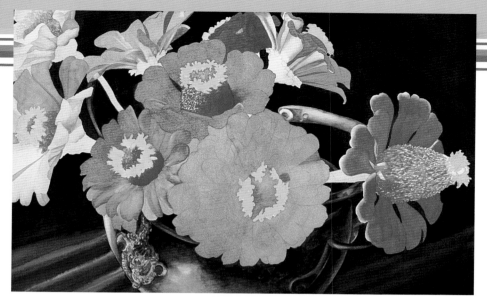

8 Darken the Background

Increase the amount of Indigo in the mixture of Indigo, Sepia and Permanent Alizarin Crimson to create a cooler dark hue than the one used on the vase. Glaze the mixture onto the background with a no. 12 round to make it a solid dark, except in the lower left corner. For the lower left corner, apply several clean water stripes with a no. 10 round, then apply the dark background color to the dry areas between the wet stripes. These stripes help add interest to the otherwise static background.

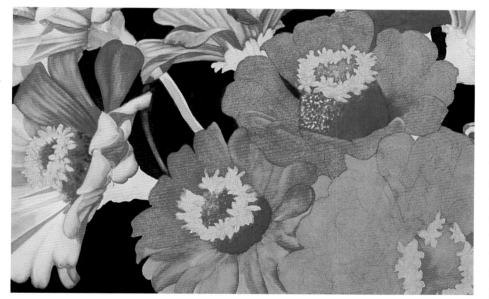

9 Detail the Yellowish Flowers

Glaze Quinacridone Magenta onto the petals touching the vase with a no. 8 round. Use a light mixture of Scarlet Lake and Permanent Alizarin Crimson for the veins. Using a no. 6 round, blend the edges of each petal. With the same brush, use a combination of the colors above with touch of Gamboge where needed in the shadowed areas. On the yellowish petals, glaze a little pigment onto the shadow, being careful to save the yellowish local color.

10 Darken the Red Flowers

Using more Scarlet Lake and a touch of Permanent Alizarin Crimson, develop the red flowers petal by petal with a no. 8 round. Glaze light Quinacridone Magenta onto the highlights with a no. 10 round. For the darkest areas on the seed pods and petals, apply a touch of Indigo with Sepia using a no. 10 round.

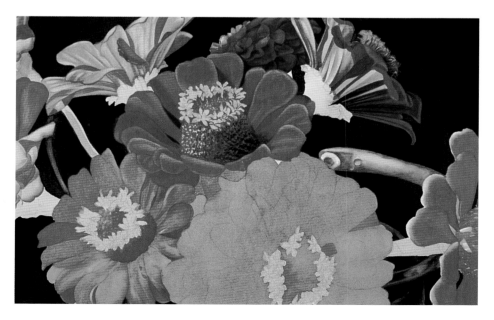

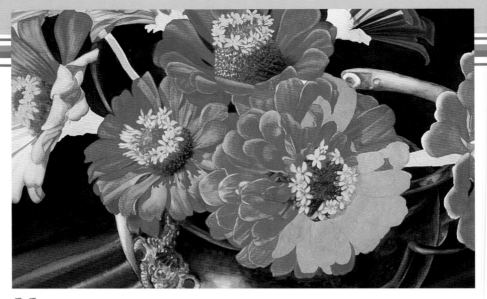

11 Preserve the Highlights

Finish the flowers on the left side and start to develop the center flowers with Scarlet Lake and a touch of Permanent Alizarin Crimson. Apply the red mixture to the center part of the petals with a no. 8 round, and gently blend out with a no. 6 round to preserve the light orange undercoat for the highlights.

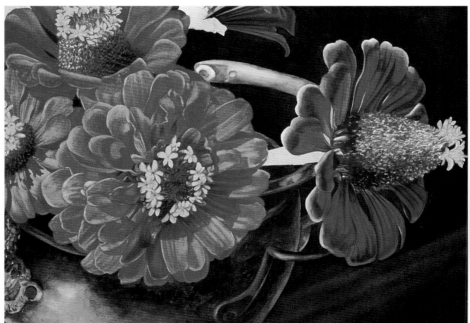

12 Finish the Petals

With a no. 8 round, apply Permanent Alizarin Crimson to define the petals, and use Scarlet Lake on the lighter red areas for more intense color. After it dries, apply a mixture of Sepia, Permanent Alizarin Crimson and Indigo with the same brush to create the backlit shadow on the petals. For the seed pod, use the same colors with a choppy brushstroke. Saving lighter spots on top and darker values on the bottom helps define the cone-shaped seed pod. Define the stamen by outlining the yellow star shapes with diluted Scarlet Lake using a no. 6 round.

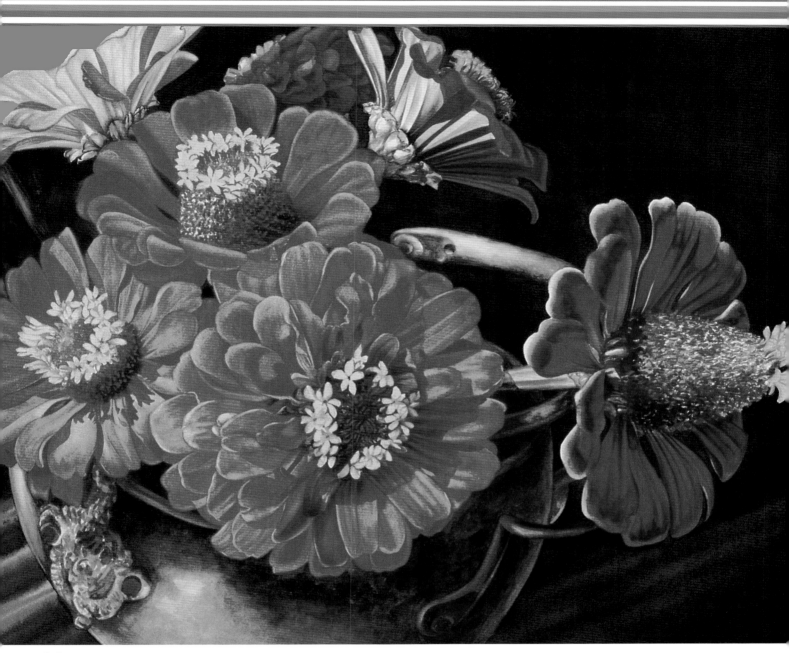

13 Finish the Painting

Complete the painting by glazing a mixture of Sap Green and all the colors used in the petals onto the stems with a no. 6 round. Correct any of the values or soften the edges to your taste.

SUMMER ZINNIAS
14" × 21" (36cm × 53cm)
140-lb. (300gsm) cold-press Arches

Develop Reflections and Textiles

One of my favorite flowers to grow is the sunflower. I even eat quite a lot of sunflower seeds! I usually think of these intense yellow-orange flowers against a clear blue sky—two naturally occurring, nearly complementary colors. Here, I want to introduce other objects with sunflowers rather than a blue sky to create a darker, more intense feel.

Set up the sunflowers with other materials: fabric with an interesting texture, a polished stainless steel pitcher and lemons. The dark textile in the background lets the flowers stand out beautifully. Also, the reflections of the flowers, lemons and fabric in the pitcher are interesting.

 Materials List

22" × 30"(56cm × 76cm) 140-lb (300gsm) cold-press Arches ✾ Bristle brush ✾ Mechanical pencil ✾ Nos. 6, 8, 10 and 12 rounds

 Color Palette

Bamboo Green (Holbein) ✾ Burnt Sienna (Winsor & Newton) ✾ Cadmium Yellow Light (Holbein) ✾ Gamboge (American Journey) ✾ Indigo (Holbein) ✾ Permanent Alizarin Crimson (Winsor & Newton) ✾ Prussian Blue (Daler-Rowney) ✾ Quinacridone Burnt Orange (Daniel Smith) ✾ Quinacridone Gold (Winsor & Newton) ✾ Quinacridone Violet (Daniel Smith) ✾ Sap Green (American Journey) ✾ Scarlet Lake (Winsor & Newton) ✾ Sepia (Holbein)

Reference Photo

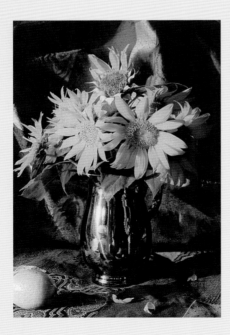

Drawing
Outline as much of the larger elements as possible. The composition is very busy with all the little elements, so find the larger elements and ignore the small ones.

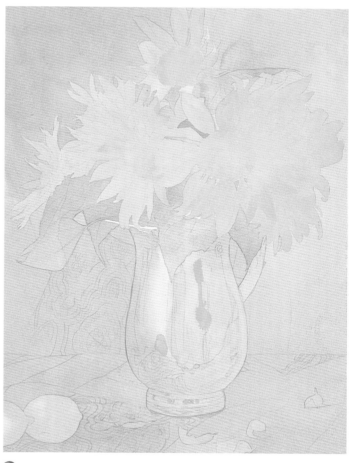

1 Underpaint the Flowers and Leaves

Apply Cadmium Yellow Light wet-into-wet onto the flowers, petals and lemons with a larger brush—at least a no. 12 round—for a fast application. Mix a touch of Bamboo Green into the yellow on your palette to make a lime green for the leaves. Using a green with a yellow tint creates harmony between the petals and the leaves.

2 Underpaint the Background

With your no. 12 round, apply thinned Quinacridone Gold wet-into-wet to create the first undercoat for the dark reddish background and vase. Be sure not to apply paint to the highlight on the pitcher.

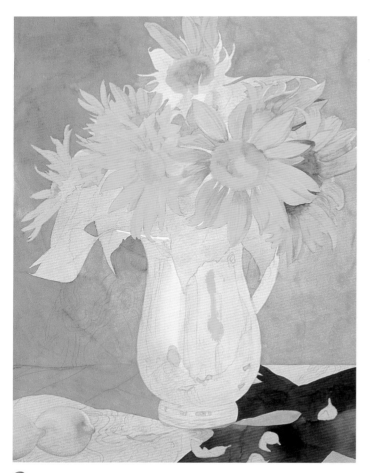 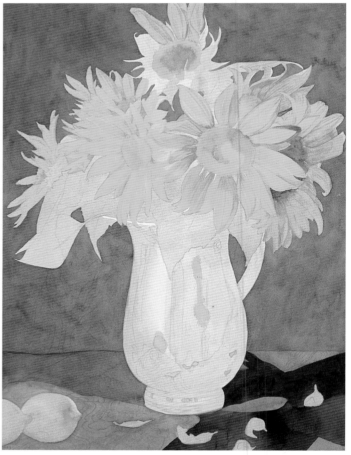

3 Fill in the Background and Define the Flowers

Glaze a thinned mixture of Permanent Alizarin Crimson and Quinacridone Burnt Orange onto the background with a no. 12 round for the dark reddish textile, and Gamboge on the flower for a deeper yellow. Allow the paper to dry between applications on the background and the flowers.

Alternately glaze Scarlet Lake and Gamboge onto the flower petals with a no. 10 round.

4 Calm the Background

To differentiate the background from the foreground, apply a flat wash wet-into-wet of a thinned mixture of Indigo and Quinacridone Violet over the background with a no. 12 round. Add water or pigment to adjust the intensity and hue until you see a mixture that properly complements your yellowish orange hue. The bluish hue calms the background, but the red shows through enough to create a warm feeling.

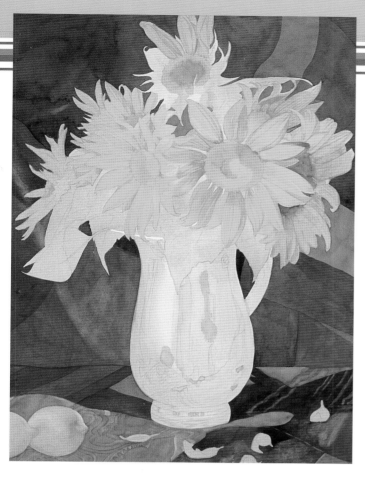

5 Divide the Background Color

Begin work on the fabric by glazing a mixture of Permanent Alizarin Crimson and Quinacridone Burnt Orange onto it with a no. 12 round. Glaze Prussian Blue onto the cooler spots. Mix Burnt Sienna and Prussian Blue on your palette to create a brown, and glaze it onto the background with a no. 12 round. Scrub some of the dark pigment off the paper with a bristle brush to restore the highlight lost in the heavy glazing, and apply Gamboge to the highlight on the bottom left with your no. 12 round. Follow the lines you can see in the fabric and freely invent the design of the darker background.

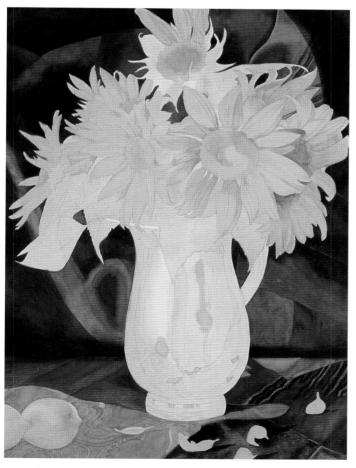

6 Develop the Value of the Fabric

To warm the deeper values of the fabric, mix Permanent Alizarin Crimson, Sepia and Indigo and gently glaze the resulting dark pigment on the fabric with a fully loaded no. 12 round. Next, use a clean, damp no. 12 round to very gently feather out the edges for a smooth transition to the lighter areas. Let the paper dry before moving to the next dark area. Continue to glaze to deepen the value of the darker fabric areas until you are satisfied with the results.

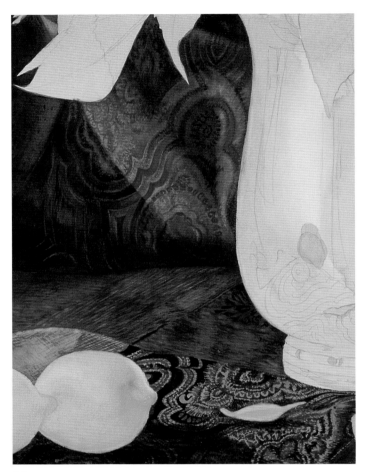

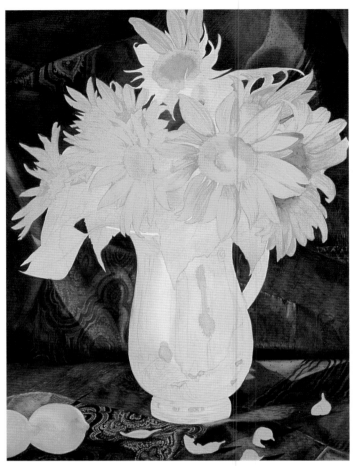

7 Detail the Fabric

Gently lift pigment off the lighter areas with a bristle brush until you have the proper values. Using a no. 6 round, suggest the grainy texture of the fabric with short, choppy dry-brush strokes alternating between Permanent Alizarin Crimson, Quinacridone Burnt Orange, Prussian Blue, Sepia and Indigo.

8 Complete the Fabric

Continue developing the many textures and elements in the background fabric using Permanent Alizarin Crimson, Sepia and Indigo with a no. 6 round until you are satisfied with the results.

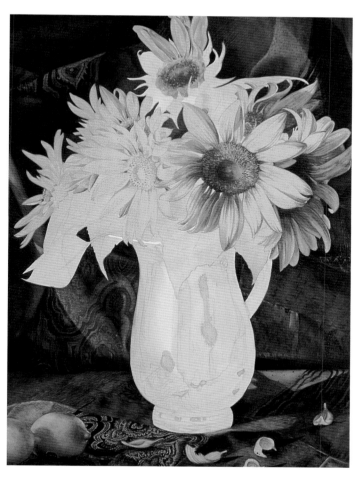

9 Develop the Flowers

Scrub the edges of the petals with your bristle brush to smooth out any hard edges created while applying the dark background. Now, using nos. 6 and 8 rounds for the delicate strokes in the dark areas between the petals, glaze a mixture of Permanent Alizarin Crimson, Burnt Sienna and a touch of Prussian Blue. Using the same colors and brushes, complete the flowers, the fallen petals on the fabric and the lemons.

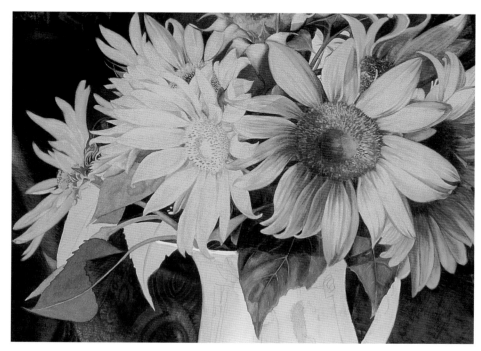

10 Work on the Leaves

Load a no. 8 round for the larger leaves and a no. 6 round for the smaller ones with a light mixture of Sap Green and a touch of Sepia and Permanent Alizarin Crimson. Glaze each leaf separately and let it dry. Glaze in the dark center vein, blending the pigment outward toward the lighter areas. Lift off pigment with a clean, damp no. 6 round if needed. Continue working on the leaves until they are complete.

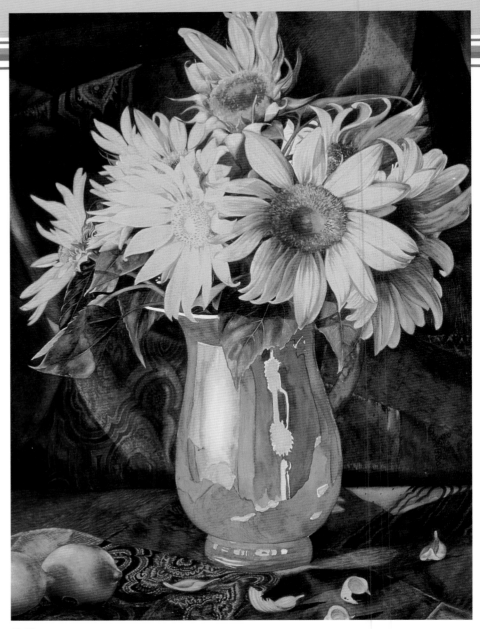

11 Start the Pitcher

The stainless steel pitcher reflects all the shapes in its surroundings. Since the surroundings are warm and dark, most of the colors reflected by the pitcher are going to be dark. The exception will be the reflected blue sky, where the surface of the pitcher will be lightened with highlights.

With a no. 10 round glaze Prussian Blue onto the highlight area, starting at the edge and blending toward the center, saving the lightest space. Glaze a mixture of Sap Green and Gamboge onto the pitcher for the reflected greenish foliage.

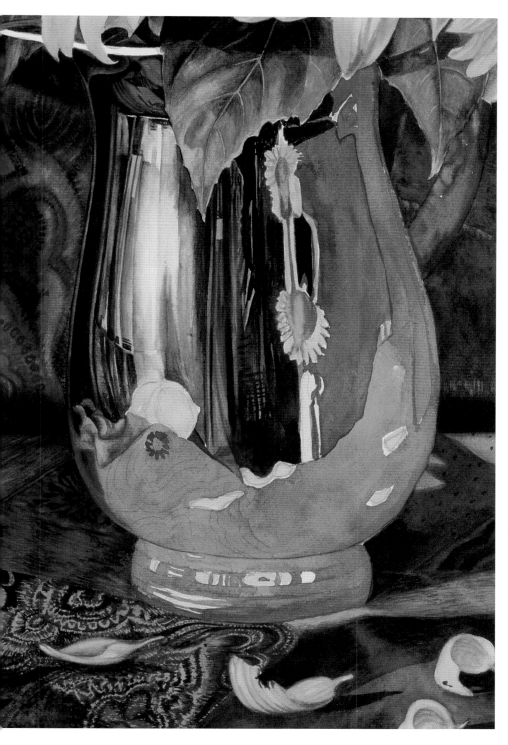

12 Develop the Pitcher's Details

Glaze the fabric colors, Permanent Alizarin Crimson and Quinacridone Burnt Orange, onto the pitcher's edge with a no. 10 round. In the darkest shadow area, glaze Quinacridone Violet over the Prussian Blue for a dark, purplish undercoat.

With precise brushstrokes, glaze heavier pigment onto the pitcher using the same color palette and nos. 6 and 8 rounds. Apply clean vertical lines in the reflection highlight with a no. 8 round to make the surface of the pitcher appear slick and shiny. Alternate the colors to produce a more exciting surface.

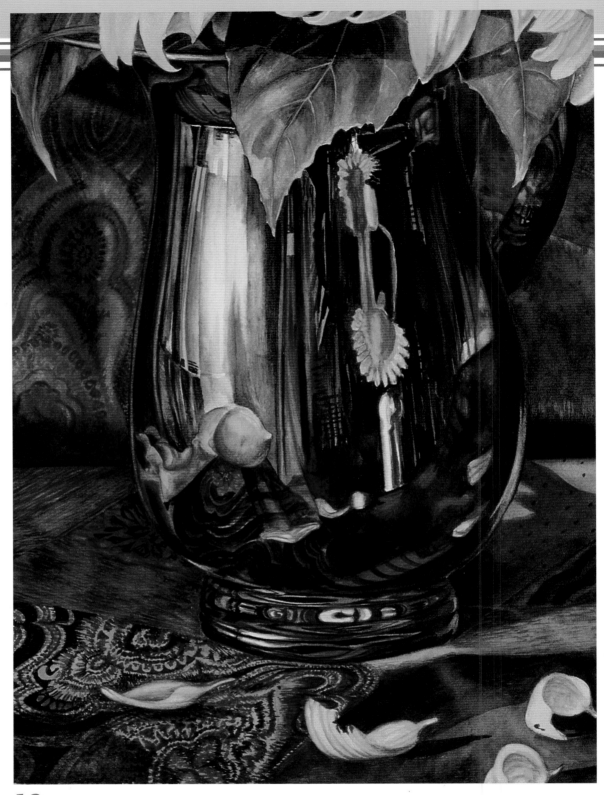

13 Develop the Foreground

Glaze Quinacridone Burnt Orange onto the lighter area of the pitcher with a no. 10 round. Use more Sepia, Quinacridone Violet and Prussian Blue for the dark colors. Finish the handle of the pitcher, too.

Shape and tone your yellow petals and lemons with a mixture of Quinacridone Burnt Orange and Gamboge and a no. 6 round. Glaze the leftover bluish color on your palette onto the rim of the vase.

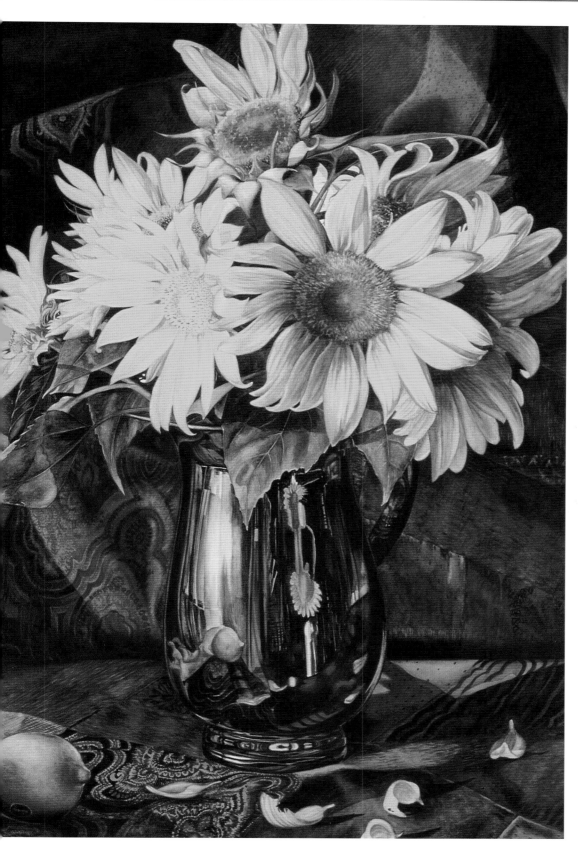

14 Finish the Painting

All the tedious little elements of the flowers, vase, fabric and lemons come together to complete the painting. After it is done, stand back and enjoy the result of your efforts.

SUNFLOWERS
21" × 29" (53cm × 74cm)
140-lb. (300gsm) cold-press Arches

Add Harmony to Your Backgrounds

Every time I start a new project, I think about how to emphasize the drama and originality of the subject matter within a harmonized composition. Sometimes I have a clear idea what I want to do and sometimes not, at least in the beginning. In this demonstration, I know that the single, large flower will be the dominant feature of the painting and withered leaves a subdominant feature. I don't want the flower to be isolated from the background, but this time I must force myself to start the painting, hoping an idea for the background will come later.

 Materials List

22" × 30" (56cm × 76cm) 140-lb. (300gsm) cold-press Winsor & Newton 3½-inch (89mm) hake Acrylic Matte Medium (Golden) Facial tissue Mechanical pencil Nos. 6, 8, 10, 12 and 14 rounds No. 1 script liner Rich Pale Gold Powder (Schmincke) Table salt

 Color Palette

Bamboo Green (Holbein) Burnt Sienna (Winsor & Newton) Cadmium Yellow Light (Holbein) French Ultramarine (Winsor & Newton) Gamboge (American Journey) Indigo (Holbein) Permanent Alizarin Crimson (Winsor & Newton) Quinacridone Gold (Winsor & Newton) Quinacridone Violet (Daniel Smith) Sap Green (American Journey) Sepia (Holbein)

Reference Photo

Drawing
Draw the outlines of the flower and leaves and the lines that indicate the patterns of light and dark in the background.

1 Apply the First Background Wash

Apply a wet-into-wet wash of a mixture of Bamboo Green and Burnt Sienna with a 3½-inch (89mm) hake to create a greenish hue. Use Cadmium Yellow Light for the lighter areas.

(I tried sprinkling table salt onto the background while it was still wet, but was not pleased with the effect. I need to develop another plan for the background.)

2 Apply the First Wash to the Leaves

Apply a flat wash of diluted Quinacridone Gold onto the withered leaves using a no. 10 round. It may look as if a green glaze was applied, but the gold just makes the background appear more greenish.

Set It Aside

If you find yourself unhappy with a painting and can't decide what the next step should be, stop working on it for awhile. Later, you may get fresh ideas that are totally different from your original plan. To speed up this process, put the painting in a place you can't avoid in your daily activities. One day, the perfect idea for finishing the painting will pop into your head!

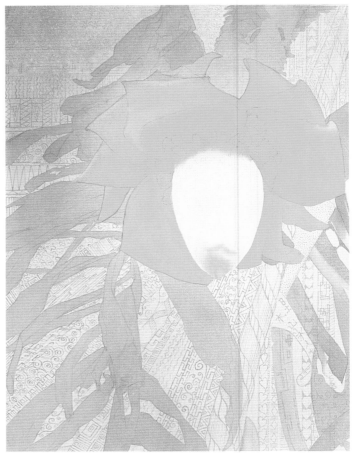

3 Change the Background

The background in the reference photo needs to be replaced with something more exciting and fun (my first attempt with salt didn't turn out). The new background plan takes a dramatically different direction: patterns and shapes created with gold powder. The values can be adjusted later.

Create an equal mixture of Matte Medium and water on your palette, and add in the gold powder. Using a no. 1 script liner, fill the background with designs you like.

4 Apply an Undercoat to the Flower

Apply a flat wash of Gamboge onto the flower petals and stamen with a large no. 14 round for fast application. This yellow undercoat will help create the rich, warm color of the banana flower.

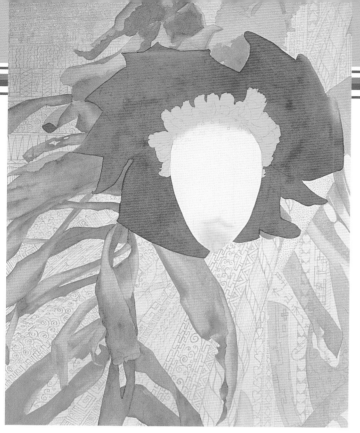

5 Apply a Wash of Red

Apply a flat wash of diluted Permanent Alizarin Crimson onto the withered leaves for a livelier effect, and thicker pigment to the petals. Use a no. 10 round for the smaller areas and a no. 12 round on the larger ones for faster application. The Permanent Alizarin Crimson creates a darker orange hue on the petals and a brownish red color on the leaves because of their different undercoats.

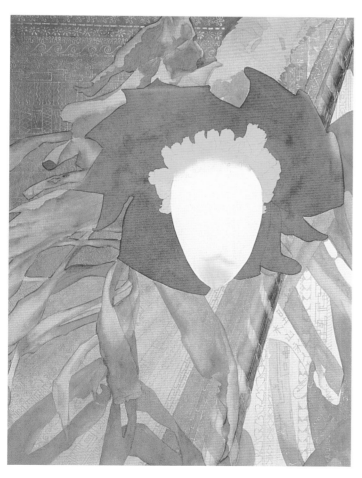

6 Unify the Background

Alternating Burnt Sienna, Permanent Alizarin Crimson and Sepia, glaze diluted pigment onto the background with a no. 12 round. The top left corner is going to be darkest, and the color gradually will lighten as you go counterclockwise. On the right side of the vertical line, apply Sepia with a no. 12 round to create movement.

(At this point, I don't have any specific plans for what I want to do with this background—I'm leaving it to instinct!)

Detail

7 Define the Background Colors

Using a no. 12 round and alternating between Permanent Alizarin Crimson, Sepia, Sap Green and Gamboge, start to develop the bands in the background. Using deeper values of otherwise muted colors brings out the details of the gold powder designs and patterns vividly. Have fun with all the little details. Complete as much of the background as possible with these colors.

Detail

8 Finish the Leaves

Finish glazing the leaves using a no. 12 round with any combination of Permanent Alizarin Crimson, Sepia, Indigo, Burnt Sienna and Gamboge. Glaze a mixture of Sap Green and Sepia onto the stem with a clean no. 12 round to deepen the overall value.

9 Begin the Center of the Flower

Apply a flat wash of a mixture of diluted French Ultramarine and Quinacridone Violet to the center of the flower with a no. 12 round. After it dries, apply a flat wash of Gamboge onto the yellow part of the flower with a no. 12 round to deepen its value.

10 Apply Color to the Petals

Glaze a thick mixture of Permanent Alizarin Crimson and a touch of Sepia and Indigo onto the darker parts of the petals with a no. 12 round. For the lighter areas, glaze a slightly diluted mix of Permanent Alizarin Crimson and Sepia with the same brush. Complete the light and dark areas without allowing the paper to dry.

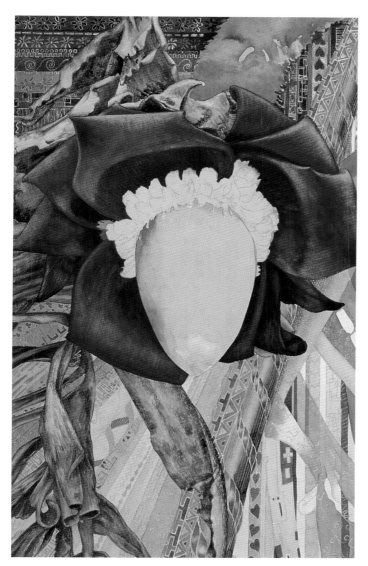

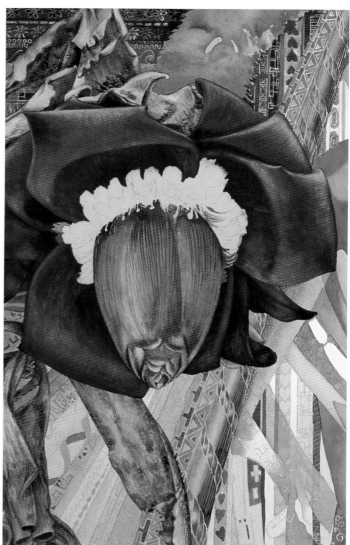

11 Create the Highlights

With a wet no. 12 round, gently loosen the pigment on the petals and dab it with a plain, soft facial tissue to remove it. Next, alternate between nos. 8, 10 and 12 rounds and glaze Permanent Alizarin Crimson onto the lighter area to bring out the reddish hue. Blend the hard edge with a clean, damp no. 8 round. For the darkest value, mix Sepia and Indigo and gently glaze it onto the darkest part of the petals. Let it dry. Then, using a wet no. 8 round, lift off some of pigment from the darkest part to bring out the veins.

12 Define the Center of the Flower

Alternate between nos. 8 and 10 rounds to glaze a mixture of Indigo, French Ultramarine and Quinacridone Violet onto the edge of the darkest part of the heart. Then, for a smooth transition, use a clean no. 8 round to blend and feather the dark area into the lighter area. Start slowly and use diluted pigment. If the result is too light, apply more layers until you attain the desired color and value.

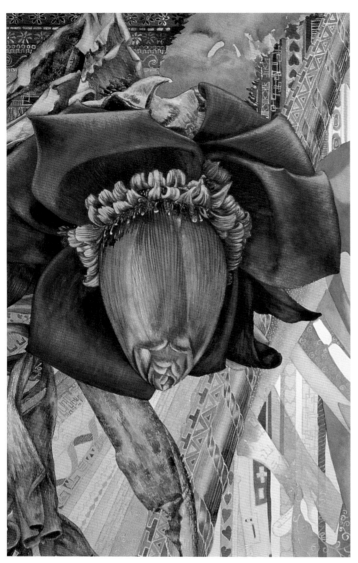

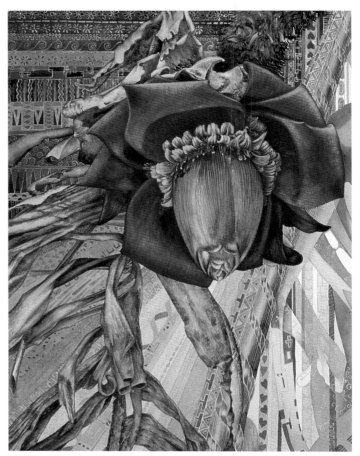

14 Define the Stem

To prepare a dark gray for the stem's undercoat, mix the left-over pigment used for the center of the flower—French Ultra-marine, Quinacridone Violet and Indigo. Glaze this mixture onto the stem and, after it dries, define the details of the twig with a no. 8 round.

13 Shape the Stamen

Using Permanent Alizarin Crimson, draw the shape of the sta-men and glaze each petal to tone down the yellow. After the stamen dries, start to develop the details with a mixture of Permanent Alizarin Crimson and Sepia using a no. 6 round. The highlights of the yellowish colors are dark enough to snuggle under the petals.

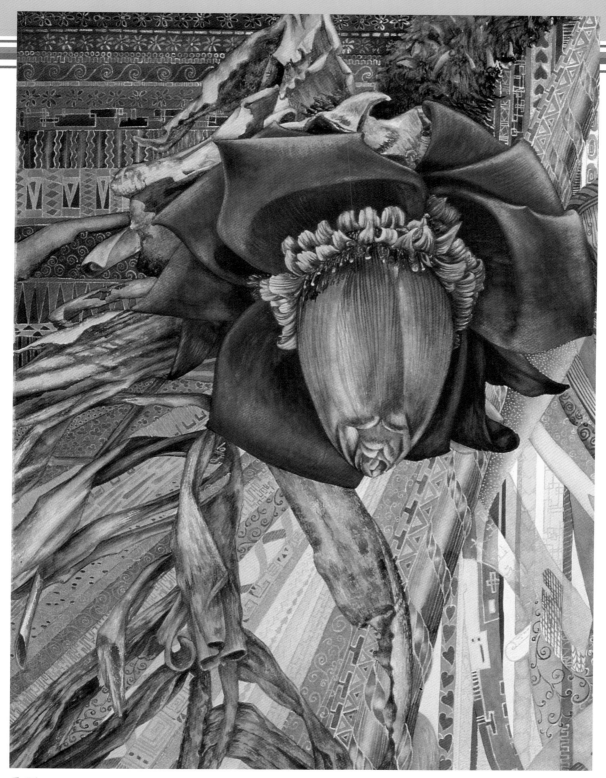

PURPLE HEART
21" × 29" (53cm × 74cm)
140-lb. (300gsm) cold-press Winsor & Newton

15 Finish the Painting

After finishing the stem, look for details you'd like to change or places that need more work. Squint your eyes and view the painting. If the values appear balanced and the patterns in the background complement the subject, the painting is done. In this case, however, the purple center of the flower stands out. You may want to introduce some purple in the background to create a better overall harmony.

CONCLUSION

I hope this book helps stimulate your creative energy for your artistic endeavors. Remember that there are no set rules for creating and expressing your art. It's all up to you. Strive to go beyond what you learn in this book, in workshops and from fellow artists.

When you work, embrace an attitude. It doesn't matter what attitude—respectful, quiet, exuberant, mean, bold, simple, or any that come to mind. If you possess an attitude, it will lead you in different directions within your creative world. Experiment with these different directions to encounter unknown possibilities and exciting adventures.

Pushing yourself beyond the limits of what you've learned will give you the experience you need to stand out.

Be true to yourself when you paint. Paint something for which you feel passion. Your sincere desire plus a thorough knowledge of your subject matter gives you the freedom to explore and experiment with colors and design without worrying about losing the elements of the subject. Your intimate relationship with your subject brings out the inner energy of your passion and personality in your paintings. So, put your mind, heart and soul into painting. I wish you luck and happiness in your artistic journey!

RED REFLECTION
22" × 30" (56cm × 76cm))
300-lb. (640gsm) cold-press Arches

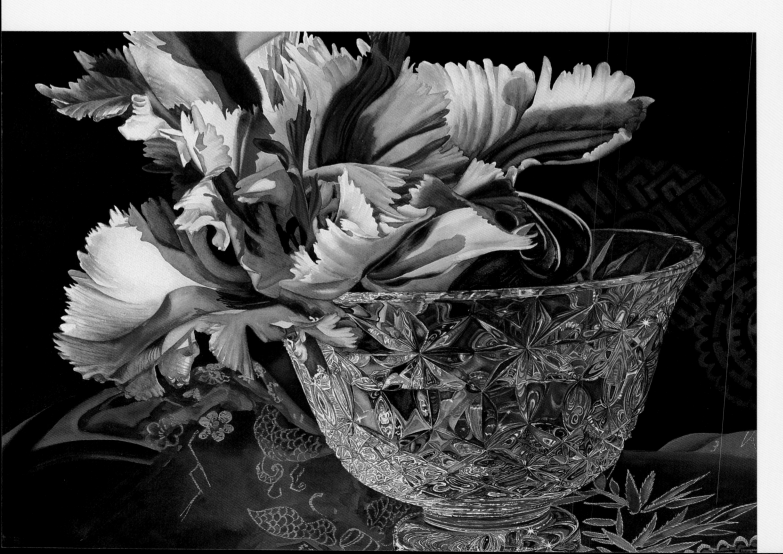